RANGELEY

THROUGH TIME

GARY PRIEST

AMERICA
THROUGH TIME®
ADDING COLOR TO AMERICAN HISTORY

AMERICA THROUGH TIME is an imprint of Fonthill Media LLC

Fonthill Media LLC
www.fonthillmedia.com
office@fonthillmedia.com

First published 2015

Copyright © Gary Priest 2015

ISBN 978-1-63500-017-7

Typeset in Mrs Eaves XL Serif Narrow
Printed and bound in England

Connect with us:
 www.twitter.com/usathroughtime
 www.facebook.com/AmericaThroughTime

AMERICA THROUGH TIME® is a registered trademark of Fonthill Media LLC

INTRODUCTION

Rangeley was first settled in 1817 by Luther Hoar. By the time that Squire James Rangeley Jr. arrived in 1825, there were several additional settlers here. The squire was a kind man who allowed the settlers to remain in place while helping them build mills and a new road to Phillips. He moved to Phillips in 1841 and later to Portland.

The town was incorporated in 1855 with the name Rangeley. The early settlers were farmers in the summer and woodsmen in the winter. About 1860 Elias Haley opened his farmhouse, located about where the Rangeley Inn sits in 2014, to guests, thus becoming the first hotel in Rangeley. At that time Haley owned the majority of the land between his house and the current Kennebago Road. As the demand for goods and services increased, local residences began opening businesses and erecting homes on land extending to the west, which been had acquired from Haley.

Lumbering had begun in the early 1840s when David Pingree purchased several thousand acres of timberland in the area. In the 1850s he constructed Upper and Middle Dams to control the water flow and enable him to float his logs to market. It was soon after that the fate of Rangeley changed forever: in 1867 George Shepard Page caught seven trout weighing a total of fifty-two lbs! Harvard Professor Louis Agassiz confirmed they were brook trout, the word quickly spread about the "big trout" in the area, and the influx of fishermen began. Hotels and camps were built to accommodate them and Rangeley became a "destination."

As time went on, these visitors brought their families; many purchased land and built summer cottages with the "Gilded Age" era peaking between 1900 and 1920. The Great Depression, discontinuance of the railroad and WWII all contributed to the decline of the "big hotel" era. After WWII the lifestyle changed: automobiles became available again, new super highways were built, wages grew and the younger generation desired to travel around, exploring our beautiful country. As the older generation – who were inclined to vacation in the same place – passed on, the large hotels and their camps saw their business decline and slowly gave way to new motels. This process has reversed in the last few decades and second homes now constitute the majority of residences in the Rangeley region.

I have organized this book on Rangeley beginning in Greenvale with the Civilian Conservation Corps (CCC) camps, continuing along Route Four into downtown Rangeley, through town to the Sunrise View Farm and then skipping to Oquossoc for a tour of the downtown there. There are a few homes and businesses on side streets off Main Street that are included, but I hope that you will be able to follow the route.

Time has changed Rangeley in many ways, with landscape being the most notable. In the late 1880s and early 1900s there were lots of open spaces, fields were everywhere. Today much of those fields and pastures have returned to woods making it extremely difficult or impossible to replicate the original photos. There are several instances in the book where this phenomena stands out.

If you have any comments or corrections concerning the book, I can be reached at gnpriest@aol.com or Rangeley Lakes Region Historical Society, POB 521, Rangeley, ME 04970.

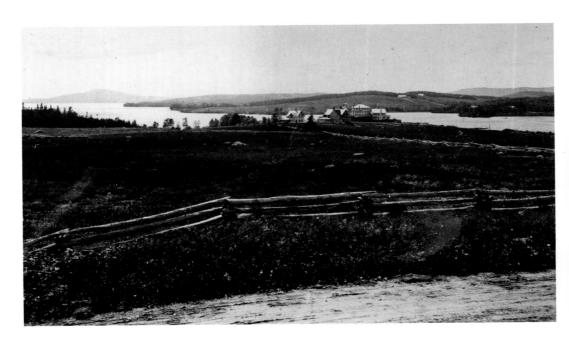

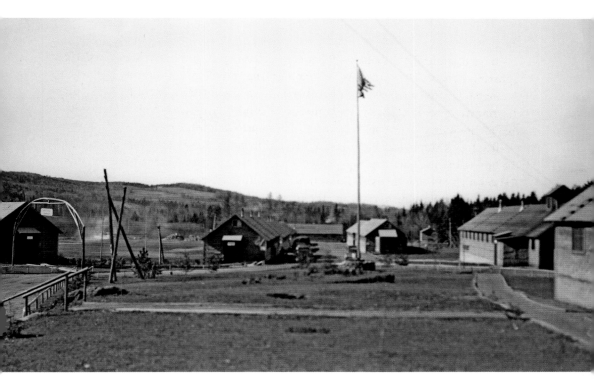

CIVILIAN CONSERVATION CORPS CAMPS: In the mid-1930s the US Government built a CCC camp in Greenvale to house workers, primarily from Rhode Island, who were sent here to work. The CCC men built Route 16 from Pleasant Island Camps to Errol, NH; the Rangeley Airport; and Route 17 from Oquossoc to Byron as well as several other projects. Harold Ferguson purchased the property and in 2014 most of the land was owned by his descendants.

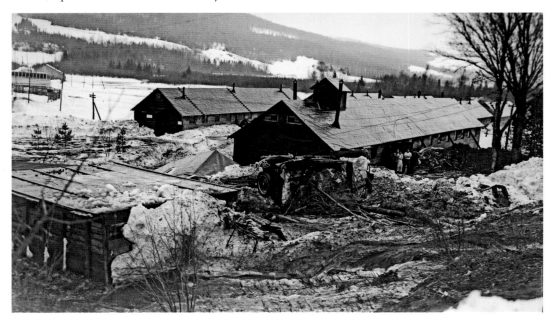

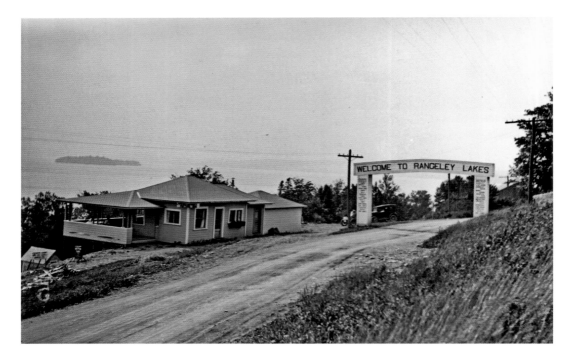

SALMON LEDGE: Salmon Ledge Camps were operating in the early 1920s when the Welcome to Rangeley sign was erected at the town line. The two pillars supporting the overhead sign contained the names of many hotels and camps operating at that time. The driveway was like a bypass and trucks carrying oil tanks would not fit under the sign and tried to use the driveway. Annie Boch, the camp owner, laid down in her driveway to prevent the trucks passage and the sign had to be removed.

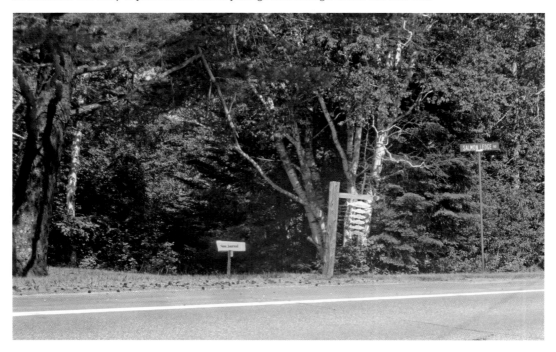

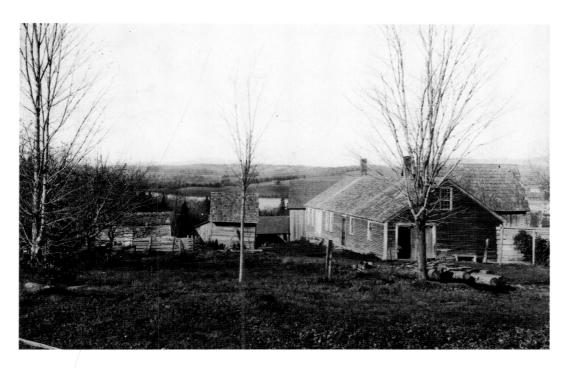

HAL ELLIS FARM: Ellis operated a dairy farm here beginning in 1920 and delivered milk to residences, stores and hotels. Local residents prized the amount of cream of the top of each bottle! The farm remained in the family until 1982 and in 1999 Dave McMillan relocated his Rangeley Family Dentistry to the remodeled old farmhouse.

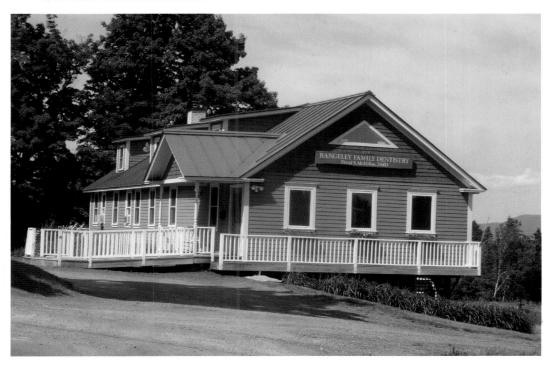

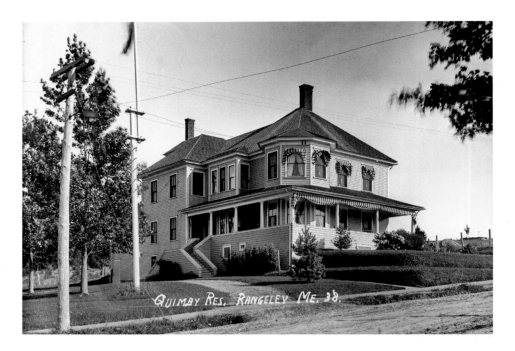

WILLIE QUIMBY HOUSE: One of the finest homes in Rangeley was erected in 1902 by Willie Quimby. The boards on the first floor were of yellow birch; the hall, stairway and dining rooms were of brown ash, the kitchen and sleeping rooms were also finished in birch. The living room had a brick fireplace. The rooms on the second floor were done in clear spruce. The building was torn down in the 1960s and the lot remained vacant until 2009 when the dwelling that is pictured was built.

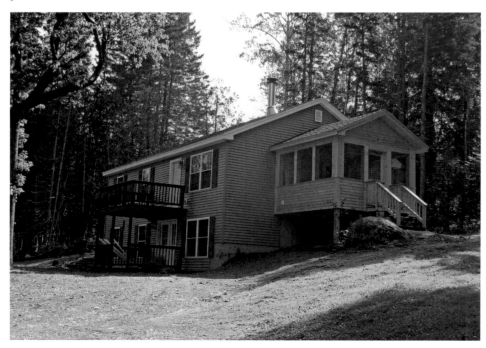

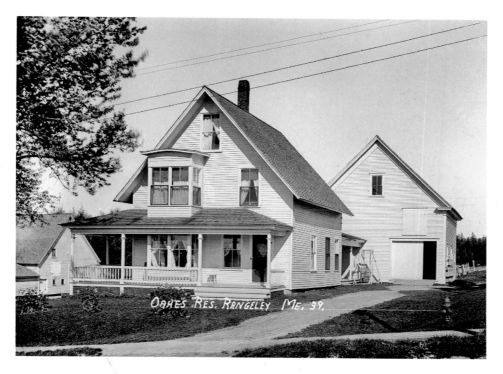

BAKER TUFTS HOUSE: This home was built in the late 1870s by Tufts where he operated a boat building business on the first floor. The boat business was relocated in 1882 and the house sold to George Oakes. Harold Spiller bought the property in 1937 and it still remained in the family in 2014.

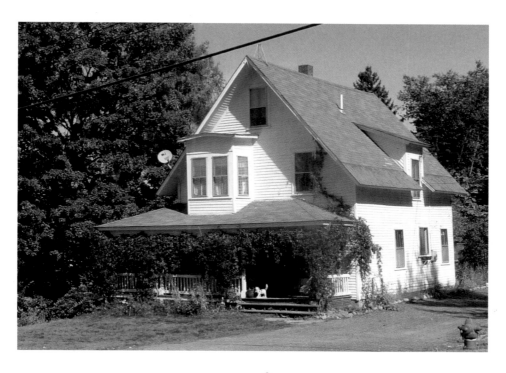

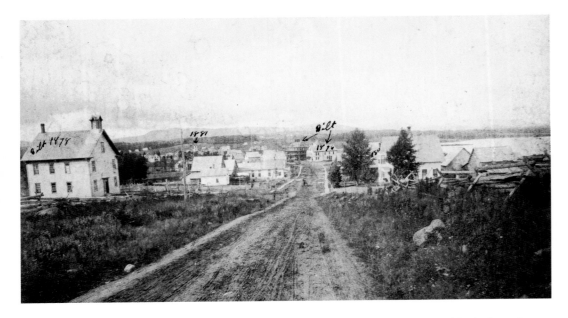

FIRST SCHOOLHOUSE: The original building (on left) was erected in 1878 to be a school for "primary" grades on the first floor and the elementary (up to eighth grade) upstairs. It was sold in 1905 and relocated. The current building, erected in 1989, has housed several businesses (auto parts store, furniture, restaurant, bottle recycling) and in 2014 housed two separate businesses, a pastry shop in the front (Deserts First Bakery) and a flower business (Sandy River Greens) in the rear.

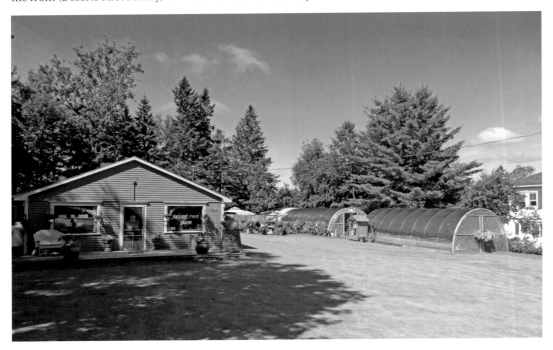

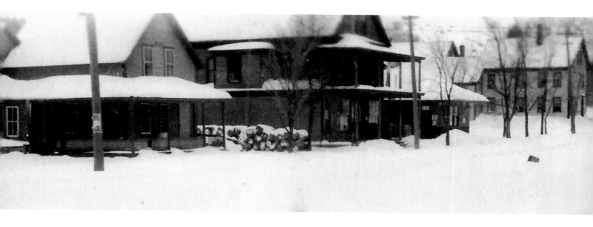

LEROY SMITH PLACE:Luther Nile sold the land to Leroy A. Smith in 1878 and the house (far right) was built in the early 1890s. Smith operated a blacksmith shop next door on what is now Depot Street – which became the site of the new Depot in 1906. It has always been a residence, but in the early 2000s it was operated as a combination web design studio and rental agency for a short time. Other buildings (right to left) are Depot, store and Urban Verrill house.

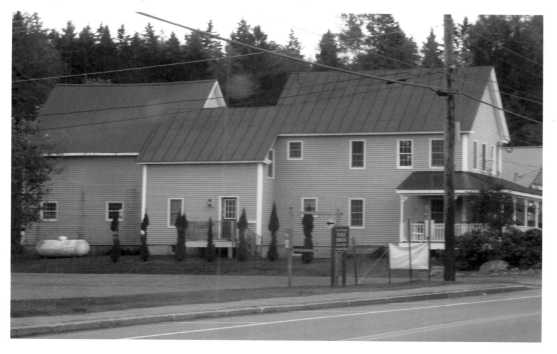

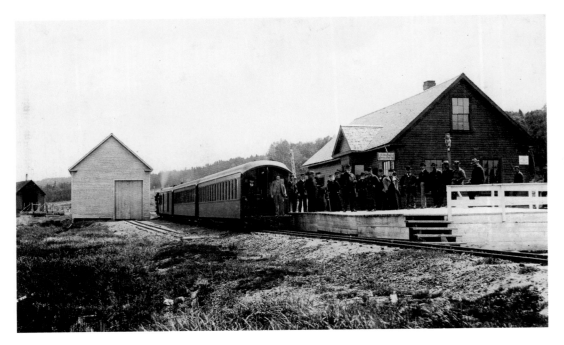

PHILLIPS & RANGELEY DEPOTS: In June 1891 the first depot for the Phillips and Rangeley RR was built several yards north of Main Street. The new depot replaced that building on the corner of Depot and Main Streets in 1906 and remained in existence until the railroad folded in 1934. The building was razed in 1938; no new building has ever been erected and it is used as a parking lot.

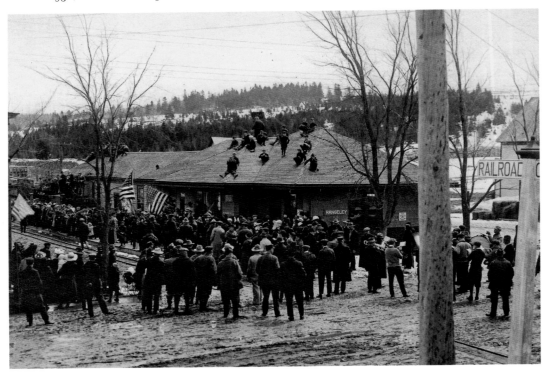

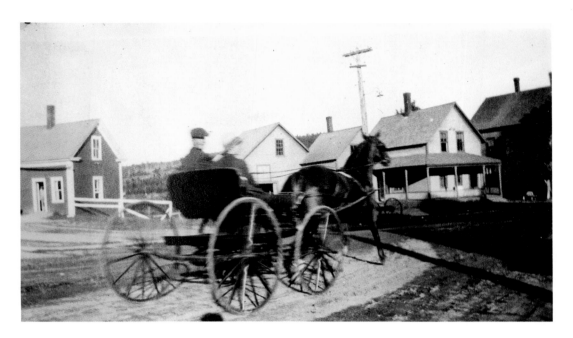

URBAN VERRILL HOUSE: This house was built about 1890 by Kendall W. Oakes. Urban Verrill resided here until 1968 when the property was sold to the owners of the Rangeley Inn. It remained a private residence until the early 2000s. Since that time is has served as a rental office, recreational vehicle rental facility and a bakery.

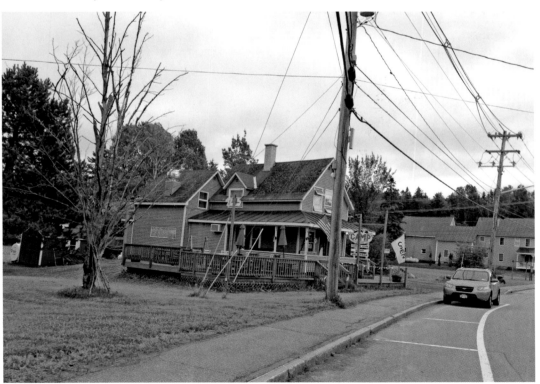

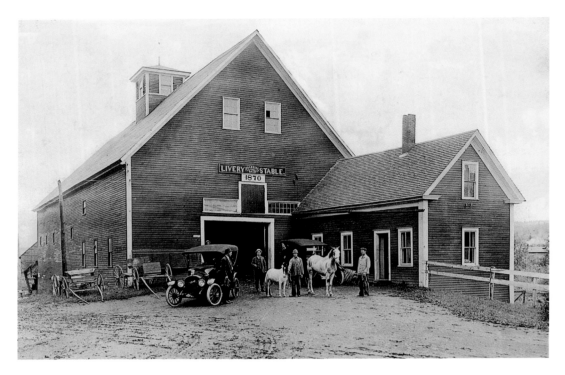

IRA HOAR'S LIVERY STABLE: The house and attached barn were erected in 1870, probably by Jeremiah Oakes. The P. Richardson Company, a buckboard company owned by Phineas Richardson, was located here for several years. Ira Hoar was operating a livery stable on this location when it burned in May 1918. The fire also caused considerable damage to the Oakes & Badger store next door. No other building has ever been built here and in recent years the site has been the location for concerts, art festivals, and the annual Blueberry Festival.

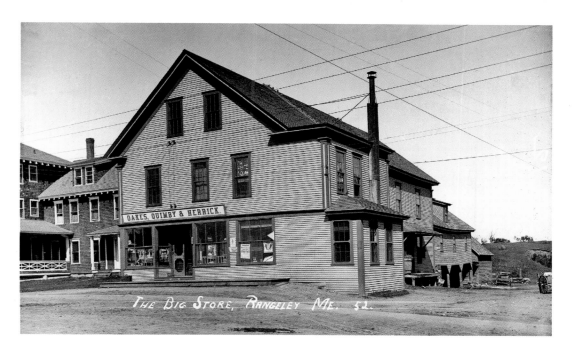

THE BIG STORE: In 1880 John A. Burke and E. A. Rogers opened a general store with a function hall on the second floor. In 1891 it was enlarged by Harry Furbish and became known as "The Big Store." It changed hands many time in the early days of Rangeley. Furbish Hall – as the function room was known – hosted town meetings, dances, and it was here that the first motion pictures were shown in town. The store was partially destroyed by fire in 1918 and rebuilt. In 1946 it became the Rangeley Lakes Motor Express terminal and the second floor was converted into apartments. It was razed in the 1960s. It has been a parking lot since then.

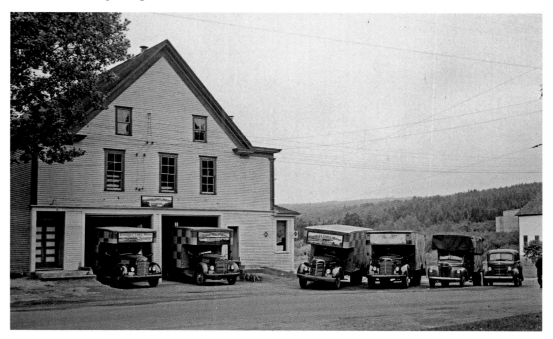

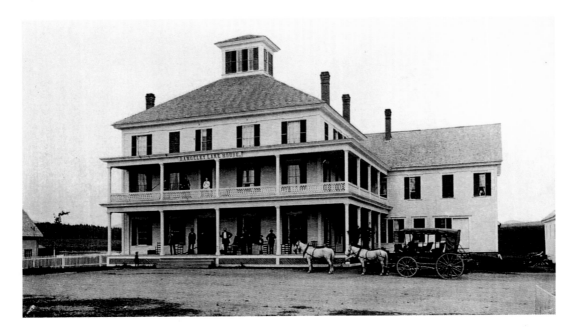

THE RANGELEY INN: The original Rangeley Lake House stood on this property until 1895 when it was moved to Marble Point. The Rangeley Tavern Corporation built the current three-story structure in 1909. It has always been a hotel and in 2014 it has thirty-five rooms, a dining room, a restaurant and a large function room with a separate motel in the rear. The main lobby has been maintained with its beautiful original woodwork as a reminder of the region's historic past.

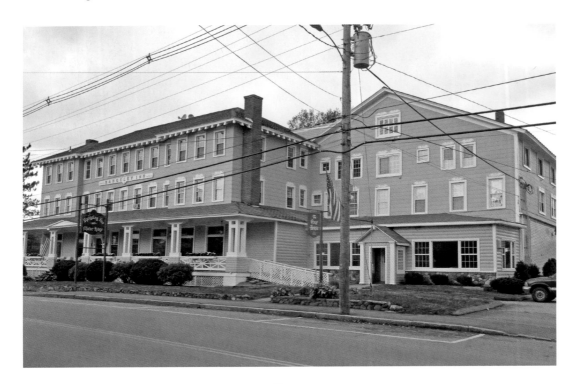

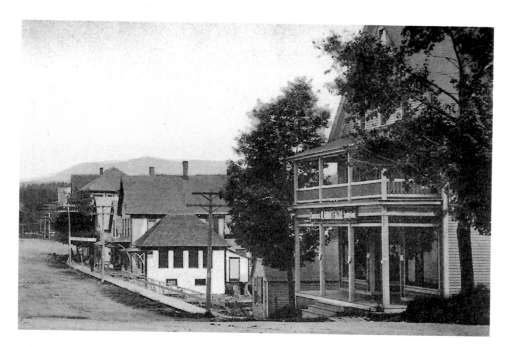

M. ABBOTT FRAZAR STORE: M. Abbott Frazar erected the three-story building in 1900 for his taxidermy business with rooms for rent on the top floors. In 1909 Willie Quimby operated a grocery store here. The building was later sold to the Rangeley Tavern Corporation, moved and attached to the west side of the Tavern building to become part of the Tavern. The old store area is now a lawn on the west side of the Inn.

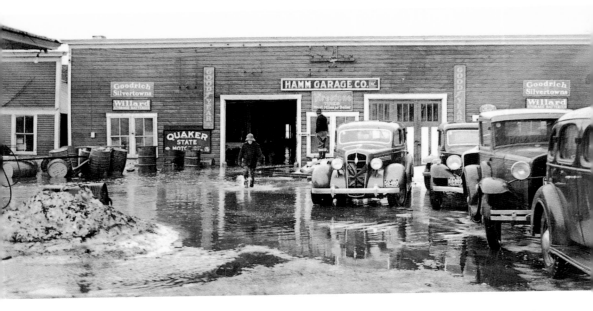

HAMM'S GARAGE: In 1916 Fred Hamm went into the automotive business and built a service station on Main Street with a garage in the rear. The old Rangeley Studio building was probably moved to an unknown location. The garage was utilized to store several of the summer residents' vehicles over the winter. The operation shut down in 1963, the storage garage was removed and the filling station converted to business purposes. At one time it was the State Liquor Store and in 2002 became the home of City Cove Realty.

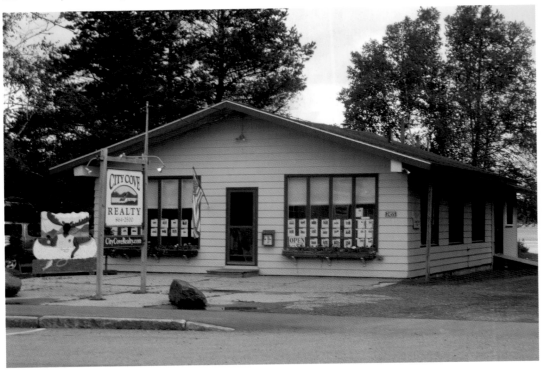

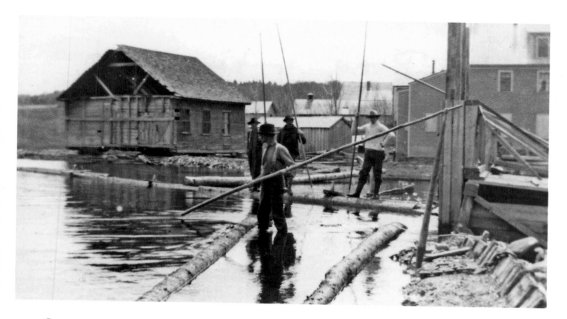

SLUICING LOGS FROM HALEY POND: Haley Pond was a gathering place for long logs before they were sluiced to Rangeley Lake. There were two sluices and in 1913 the easternmost stream was filled in and later became part of Hamm's Garage. The section along Haley Pond Stream was then acquired by the town in 1917. In 1959 Lin and Cecile Dumas moved the Pine Tree Frosty from the corner of Loon Lake Road and Main Street to here. It has operated in the summer months only as an ice cream parlor and remains a favorite stopping place for locals and tourists alike.

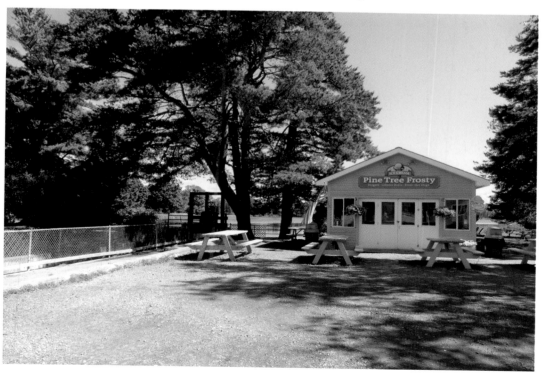

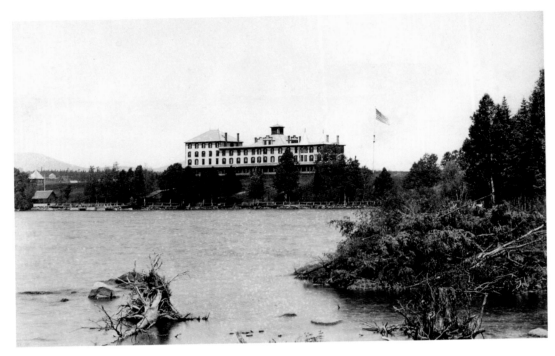

RANGELEY LAKE HOUSE: The original Rangeley Lake House was built in 1877 on the site of the current Rangeley Inn. In 1895 it was moved to Marble Point and additions were built on each end. It was the largest and grandest hotel in the area and the site of many conventions and golf tournaments. It was demolished in 1958 and private residences have been constructed there, each with an outstanding view of Rangeley Lake.

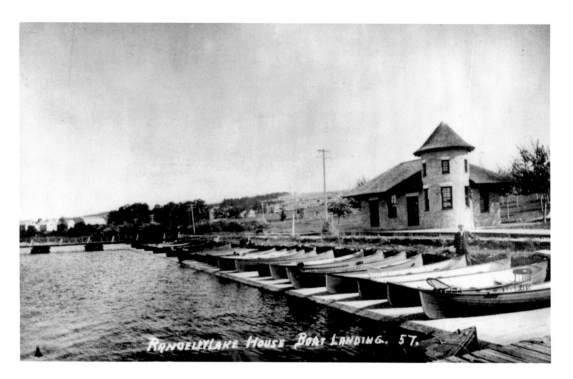

RangeleyLake House Boat Landing. 57.

MARBLE STATION: This stone railroad station was constructed in 1906 at the Rangeley Lake House as a convenience for passengers destined for the hotel. After train service was discontinued in 1934, it was retained by the hotel. It is a private home today.

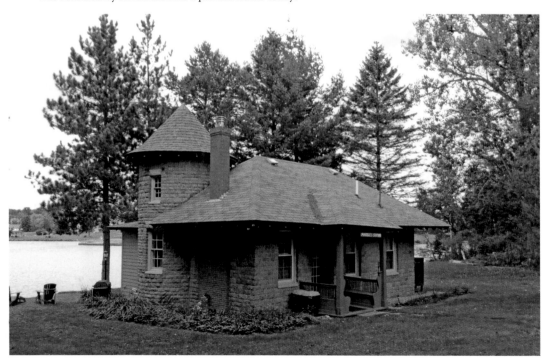

THE ARNBURG RESIDENCE: The original house and attached stable were probably built about 1900 by A. (Andrew) J. Haley. Ira Huntoon operated a livery stable here at one time. The house served mainly as a residence until the 1980s and has been a gift shop since that time. In 2014 it was Dee's Place Gift Shop. Clayton Arnburg moved his barber shop to the property in 1957 and located in next to the house. Since then it has been a gift shop, beauty salon and in 2014 it offered Massage Therapy.

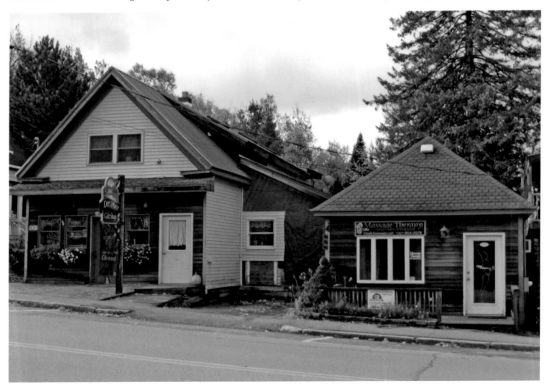

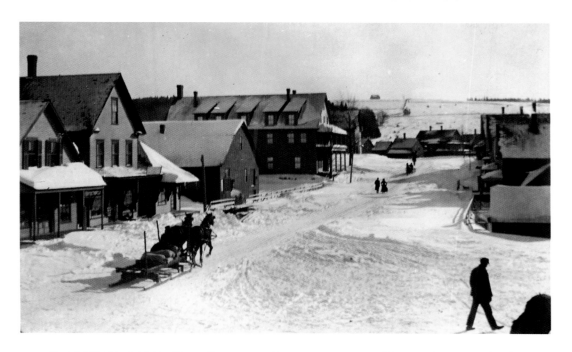

EARLY STORES FROM POND STREET TO FRAZAR BUILDING: This top photo was taken between 1900 and 1905. On the left is a store owned by Nathan Ellis, Julia Dill's millinery shop, H. A. Furbish Insurance office, Kempton Brothers mill (razed in 1906) and the Frazar taxidermy building. The 2014 photo shows Rangeley Crossings, Roger Page's gift shop and Barry Libby's Beauty Salon.

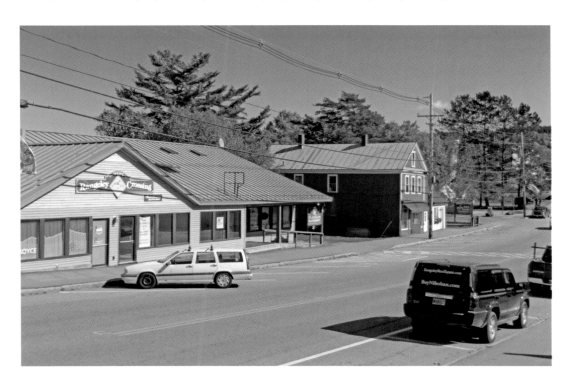

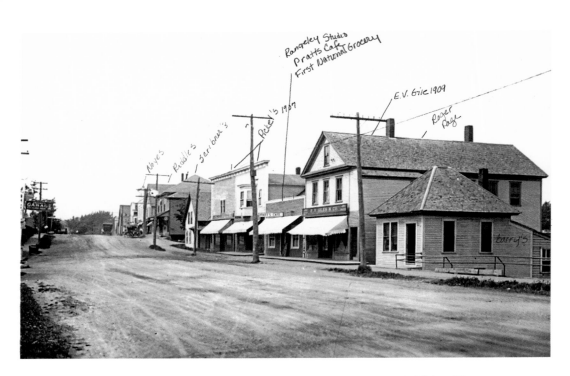

MAIN STREET: Taken about 1910, the buildings are Furbish Insurance; E. V. Gile's millinery store; Pratt's Restaurant; two buildings owned by Harry Kimball and the first J. A. Russell hardware store in the building that looks like a house. The current photo shows Barry Libby's Beauty Salon, the former Roger Page Gift Shop and the Thai Blossom restaurant.

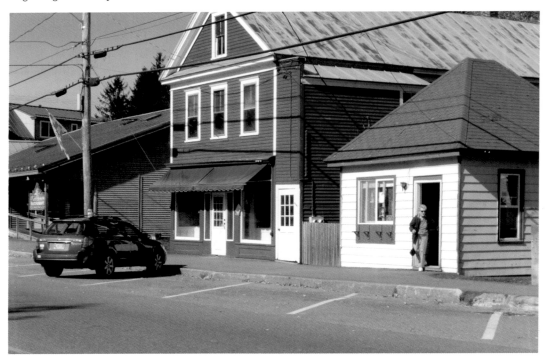

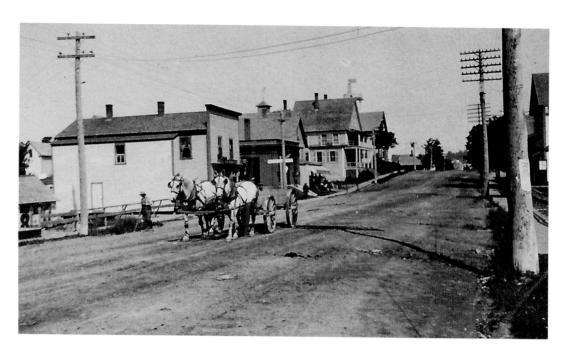

MAIN STREET: Another photo taken about 1910 opposite the previous page; it shows Peter Nicola's Store, The Rangeley Trust Company, Marchetti's Market, The Oquossoc House and the George Young House. The lower photo shows the former Elmer "Doc" Grant's restaurant, The Rangeley Lakes Region Historical Society, Morton & Furbish Real Estate and the Skowhegan Bank.

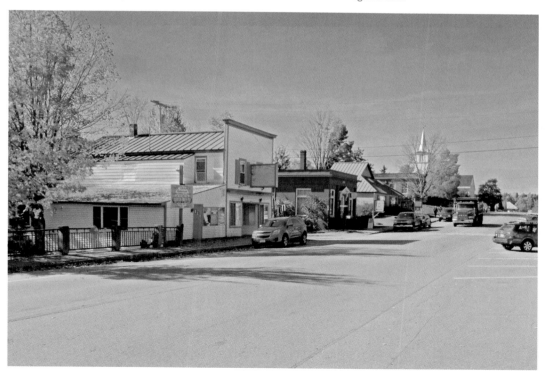

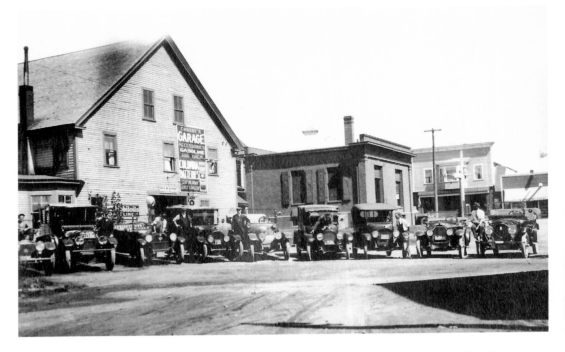

CROSBY'S GARAGE: Rufus Crosby relocated his garage business from Lake Street to Richardson Street in 1910. The garage was later operated by Samuel Clark, then Fred Hamm. The Rangeley Trust Company is on the right and across Main Street one can see the G. W. Pickel Store. The garage buildings were destroyed by Scott Morton in 1980 and the existing building was erected as a gift shop. It is now known as Bald Mountain Diner serving breakfast and lunch daily. The Historical Society building is on the right.

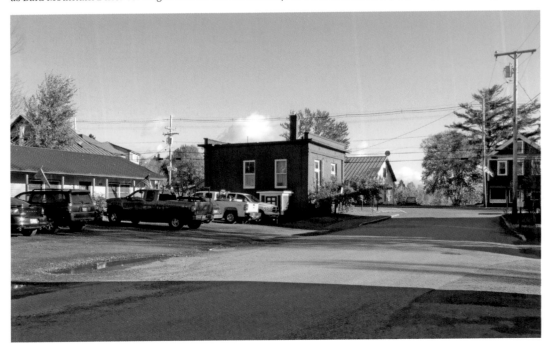

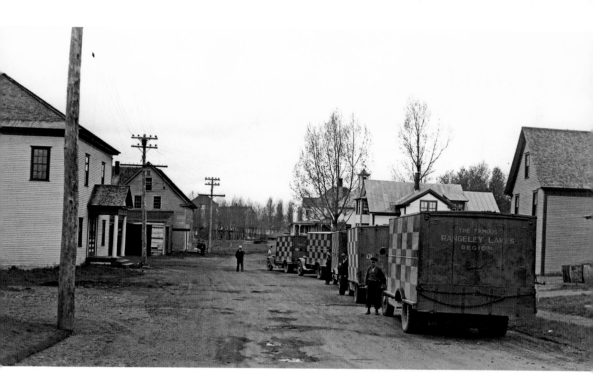

RICHARDSON STREET: The Lodge Hall, visible on the left, was originally a garage with a roller rink above which was converted into a lodge hall in 1922. Behind it is Phineas Richardson's stable, his (Richardson's) house, The Leslie Doak House and part of Crosby's garage. In 2014 we see the Lodge Hall, Morton residence, the Eastlack Home, the former "Skeet" Davenport Home and the BMC diner.

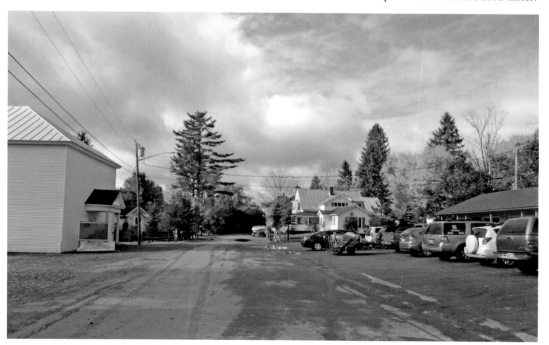

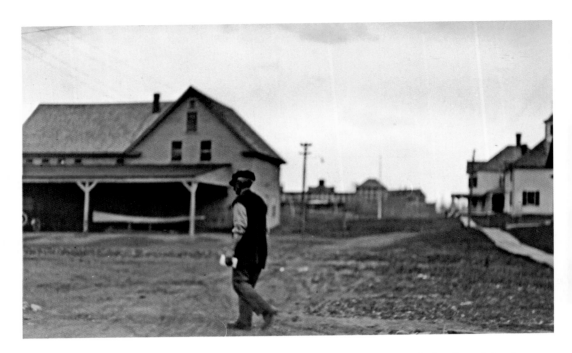

RICHARDSON'S STABLE: Phineas Richardson operated a stable on this property in the 1890s. Later the town of Rangeley operated a garage here. In 1935 Archie Carrigan bought the property and operated the Rangeley Lakes Motor Express from here. A small express office was built in the 1970s and in the 1990s it was moved and converted to a private residence; in 2014 it was the home of Scott and Nancy Morton.

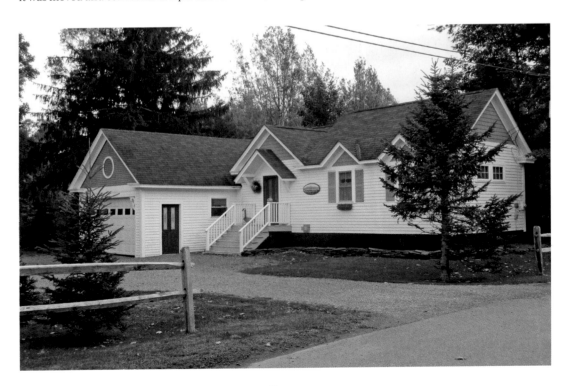

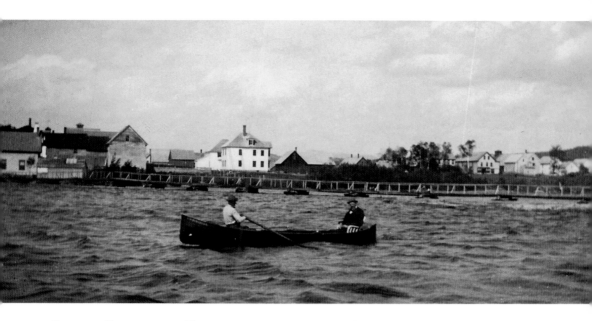

PHINEAS RICHARDSON HOUSE: Richardson, a well-established businessman, had this large home built in 1897 overlooking Rangeley Lake (white house in the center). In the foreground is the footbridge connecting the town dock with Marble Station. The house remained in the Richardson family until 1973 and is now the residence of James and Beth Eastlack.

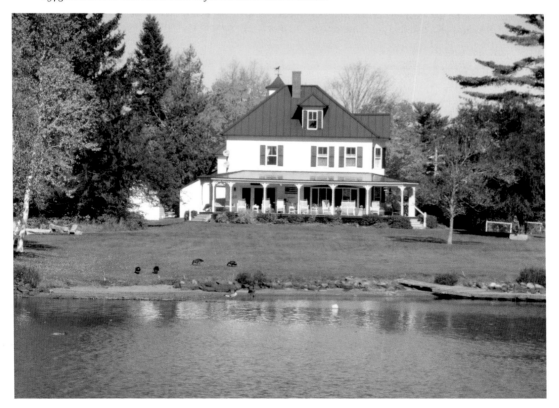

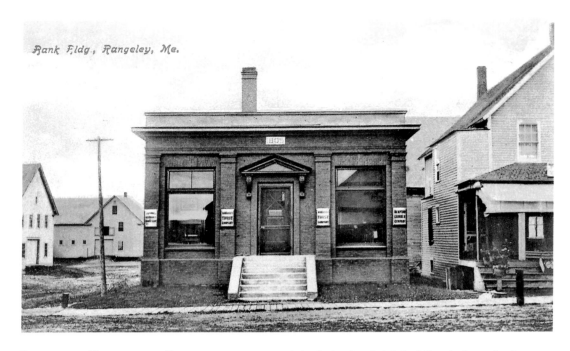

Bank Bldg., Rangeley, Me.

RANGELEY HISTORICAL SOCIETY: Harry Furbish built the first brick building in Rangeley in 1905 as a bank and insurance office. In 1927 he sold it to the Town of Rangeley and it became the town office for the next fifty years. During that time it also housed the Western Union office and the town Information Bureau. The Rangeley Lakes Region Historical Society acquired the building in 1979 and runs it today as a museum, open only in July and August.

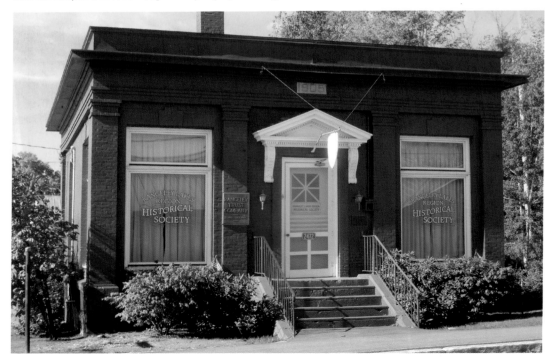

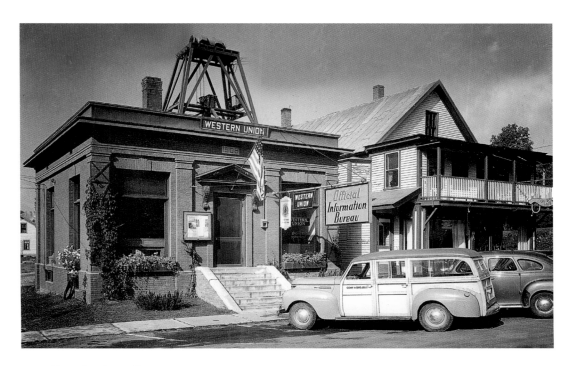

THE OX BOW CAFE: The building on the left was the Town Office and, on the right, George Young built and operated one of the two general stores in town as early as 1880. It remained a grocery store under several owners until the Ox Bow Cafe opened in 1940. After WWII it became an auto parts store, light company office and hardware store, until it was torn down in 1978. The lot in 2014 is a pathway to the Bald Mountain Diner and is the home of the Morton & Furbish Real Estate & Rental Agency.

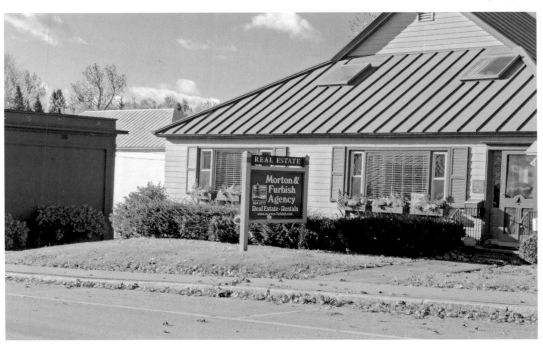

THE OQUOSSOC HOUSE: The building on the left is the Oquossoc House, the second hotel in Rangeley, built in 1877 by Abner Toothaker. It served many of the local residents and often housed a barber shop or doctor's office. John Marble acquired it in 1891 and used it as an overflow hotel when the Rangeley Lake House was full. It remained open in the winters, being the only hotel to do so. It was destroyed by fire in the 1920s and has remained a vacant lot since.

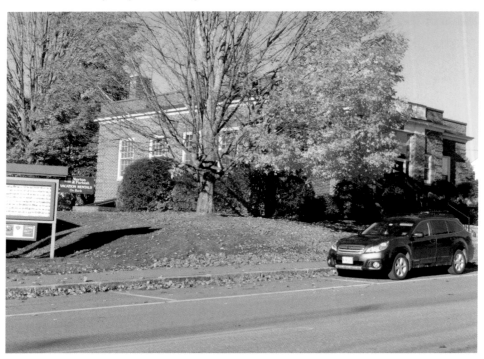

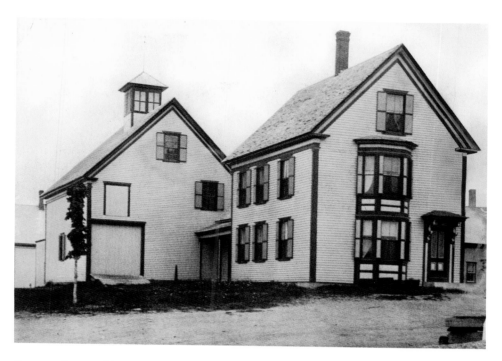

GEORGE YOUNG HOUSE: One of Rangeley's first entrepreneurs, George Young, built the original house about 1881. He was a bachelor and rented rooms and/or apartments until his death in 1916. It was operated as a livery stable for a few years and in the early 1920s the house was relocated to behind the library. The barn was detached and moved back one lot and became the Episcopal Church. A new Rangeley Trust Company building was constructed in 1925 and it has operated as a bank ever since. In 2014 it was the home of the Skowhegan Savings Bank.

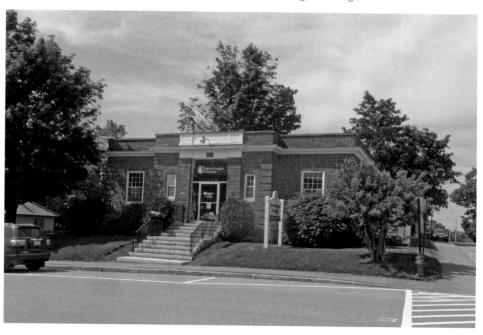

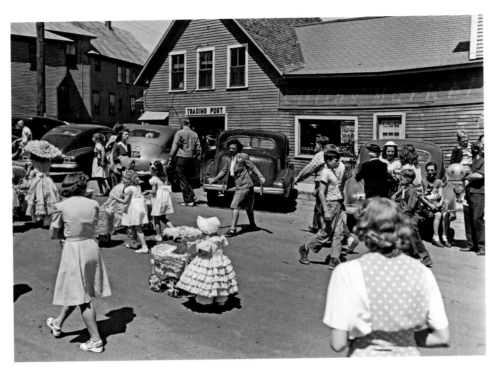

ELMER "DOC" GRANT DOLL CARRIAGE PARADE: In the background can be seen Bert Herrick's antique shop. In 1950 Chester Johnson razed the old building and constructed a new market, which became the IGA in 1957. Over the years the IGA expanded to the south taking over Moulton's Clothing Store and Pickel's Store. The IGA relocated to the top of City Hill in 2009 and the space was subdivided to accommodate several businesses. The longest tenant has been the Thai Blossom Restaurant.

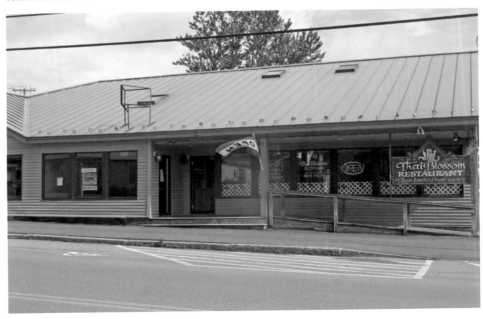

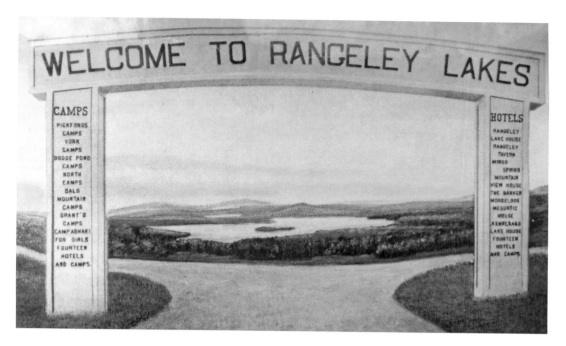

"WELCOME TO RANGELEY LAKES": I could find no factual evidence of this sign located at the foot of Dallas Hill near the junction of Route Four other than this photo. When it was removed is unknown. In 2014 the view across Route Four is from an overlook with an outstanding view of Rangeley Lake, located where the Whip Willow Farm was formerly located.

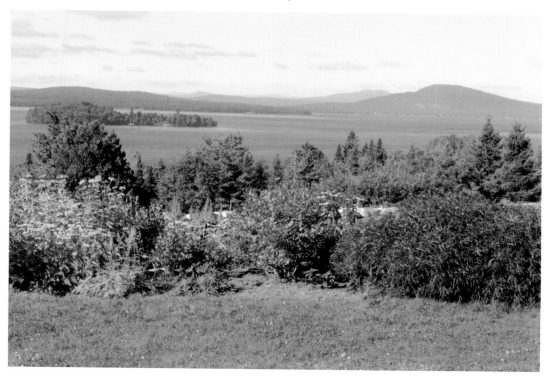

FIRE STATION #1: The town of Rangeley erected its first station on Pond Street about 1900 (building on the right). Prior to that time, the fire apparatus had been housed in various stables in town. Note that Haley Pond extends up to the foundation of the building. It remained as fire department headquarters until 2004 when the new safety building was built on School Street. The old building was dismantled in 2006 and Haley Pond Park was created.

HUNGER'S MILL: There was a small building here in the late 1940s that was called the Tinker Shop. In 1952 Richards Hunger enlarged the building and opened a wood-turning business making night sticks for policemen and, later, darts. The building was badly damaged by fire in June 1953 and immediately rebuilt. Joyce Blackwell took over the mill in 1966 and several years later she added a bottle redemption center. The building was remodeled into a nature/book store called Ecoplagicon in 1995.

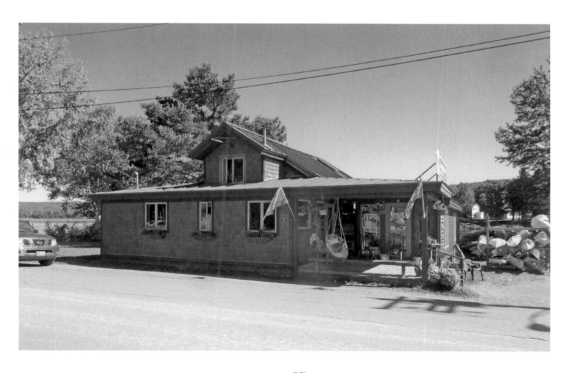

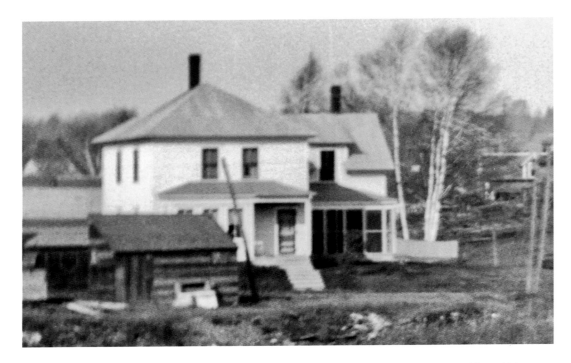

EMERY HALEY HOUSE: In 1899 J. Emery Haley erected this two-story house. He was a guide and his wife, Cora, was a dressmaker. She operated a dress-making business there for thirty years. It has always remained a residence, however, for many years there was a beauty salon on the first floor operated by several owners. It was owned by Ashley Gray, a champion wood sculptor, in 2014.

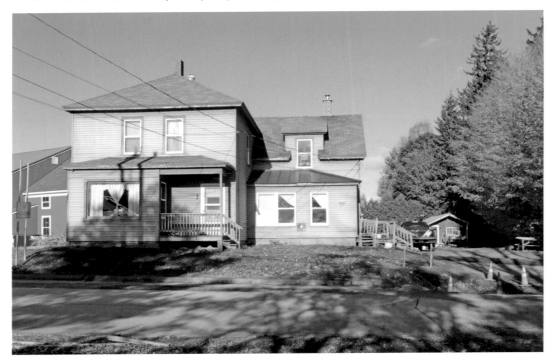

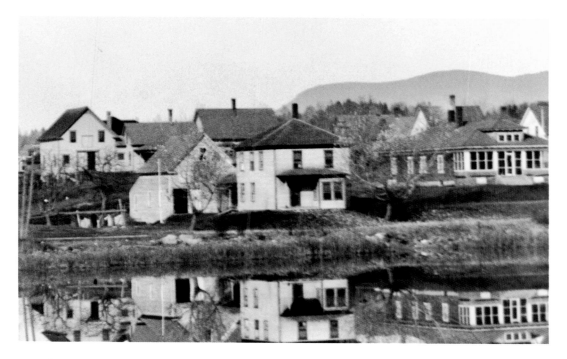

DANIEL HEYWOOD HOUSE: Heywood, a well-known guide and taxidermist, built this home in 1900. He operated his taxidermy business on the first floor and rented the upper floor. Since that time there has been a residence on the first floor and a rental apartment/business on the second. Betsy Tibbetts added the stable in 1909. (This was the home of the author when he grew up in Rangeley.)

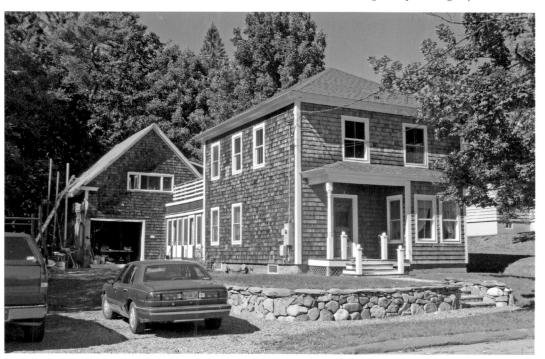

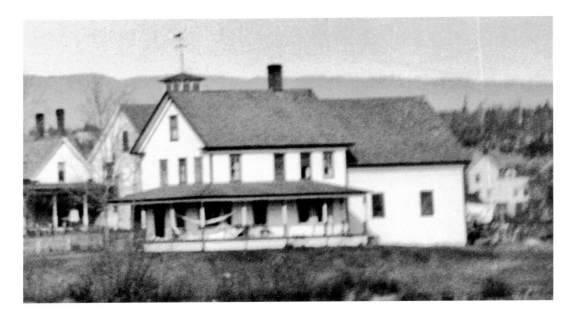

JAMES MATHIESON HOUSE: James Thompson probably constructed the original house in the 1880s. Ten influential members of the Baptist Church bought it in 1887 to be used as a parsonage. After the church bought property on Lake Street for a new parsonage, the property was sold to James Mathieson, a local guide. It has always been a private residence and for many years also housed a day care center under the direction of Sue Richards.

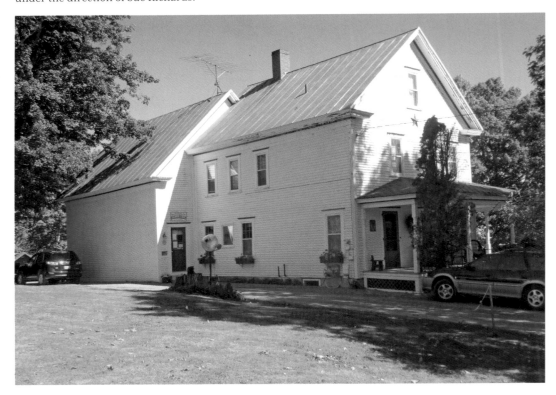

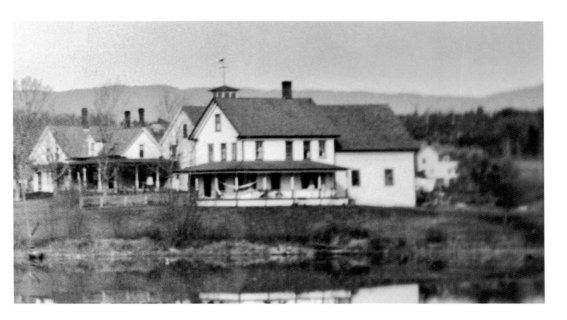

HENRY KIMBALL HOUSE: The building on the left was acquired prior to 1896 by Kimball, who built a large home with a barn. Kimball owned several hotels during his lifetime and was an influential and well-respected businessman in town. Upon his death the property passed to his son Harry and later to Florence Harnden, Henry's granddaughter. The barn was removed prior to 1950 and the house was demolished in 1954. The Church of the Good Shepherd built a parsonage there in 2000.

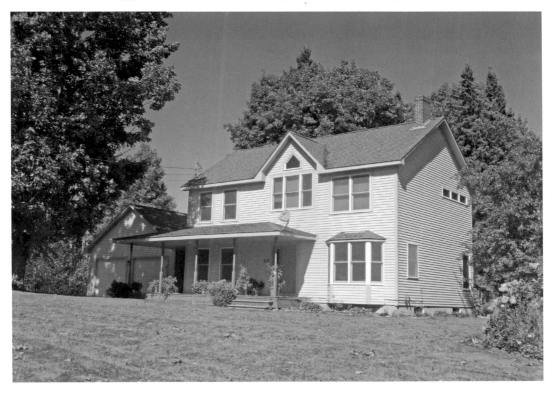

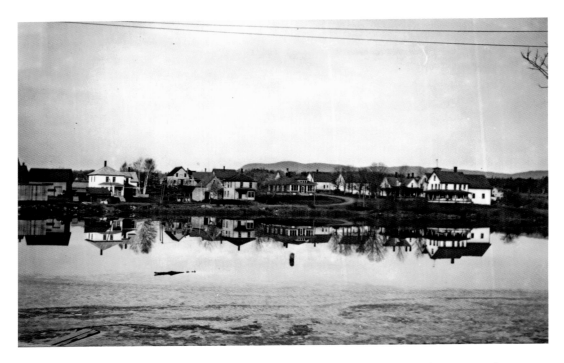

EARLY VIEW OF POND STREET: Taken about 1916, the view shows how open the area was then. The identifiable buildings starting from the left are: Emery Haley house, Daniel Heywood house, Ray Harnden house, (road curves) Charles Stuart (the local dentist), Henry Kimball house and James Mathieson house. In the 2010s trees block out most of the houses from the same vantage point.

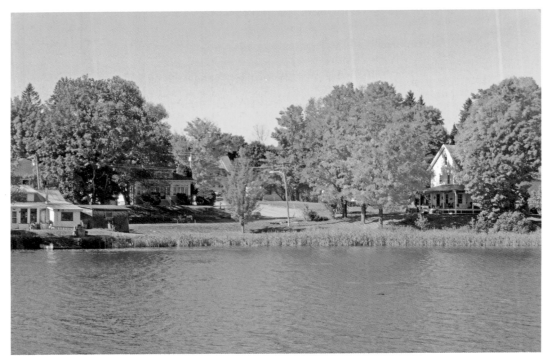

BAPTIST CHURCH: Picture taken in 1906. Construction began on the church in 1881 but it was not completed until 1883. In 1923 the building was raised three feet for a foundation and furnace. The church burned in 1941 and, due to the lack of materials during WWII, was not rebuilt until 1946. During that time services were conducted in Russell Hall over the J. A. Russell hardware store. The new church was dedicated in June 1947.

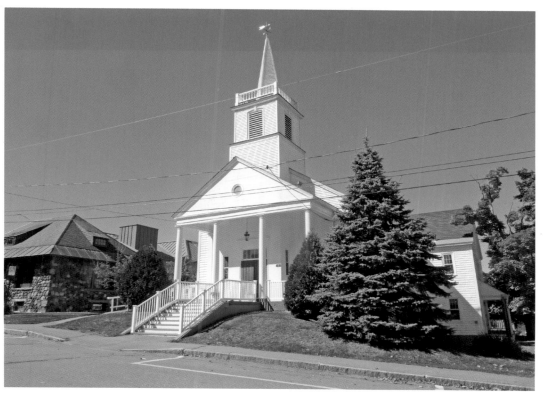

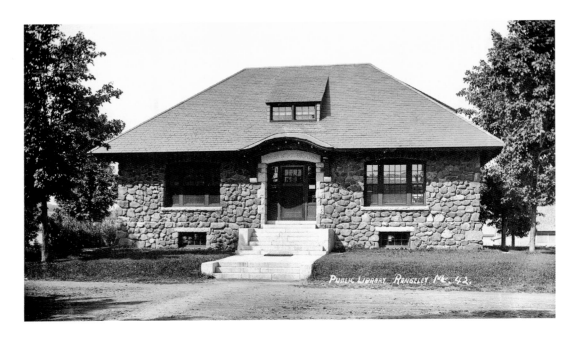

RANGELEY PUBLIC LIBRARY: The beautiful stone library was built in 1909 with the majority of the support provided by the summer residents. It is square, of colonial design, with a tiled roof, and walls of field stones. The lower level was one large room finished in cypress with large pillars and squared archways. The upper floor was used for storage and had a small assembly room. In 2002 a large addition was added to the rear which extends toward the lake and the beautiful gardens were created. It is one of the most attractive buildings in the town.

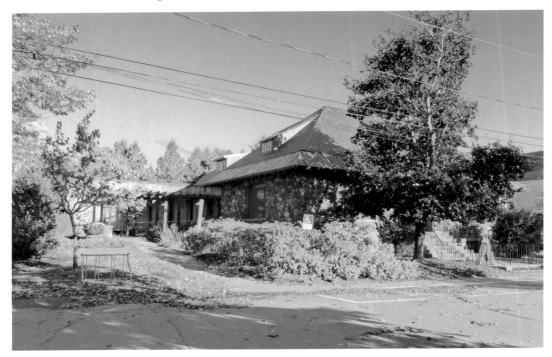

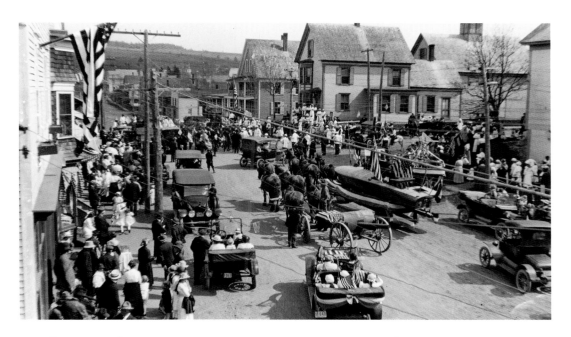

RANGELEY CELEBRATES: Rangeley is shown, likely celebrating a 4ᵗʰ of July parade about 1920. The large building in the center is the George Young House (now site of Skowhegan Savings Bank) and the structure next to it is the Oquossoc House. Note the cupola on the stable in the upper right: this building was moved over one lot and became the Church of the Good Shepherd (Episcopal) in 1920. The first services were held here in July 1921. A new church on Main Street was built in 1965 and this structure was demolished.

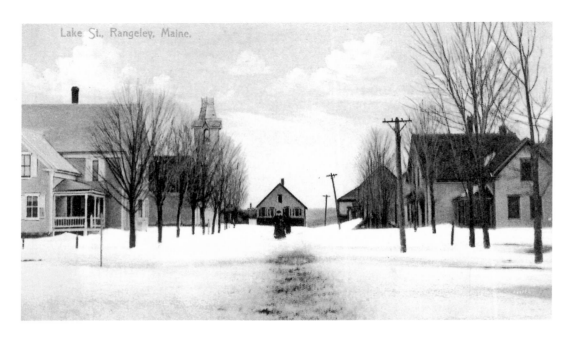

Lake St., Rangeley, Maine.

BAPTIST CHURCH PARSONAGE: The house (on the right) was built in 1884 probably by Jeremiah Oakes. He sold it to his son, Walter Oakes in 1889. Oakes raised his family here for the next fifteen years before he sold it to the Baptist Church to be used as a parsonage. It remains their parsonage to this date.

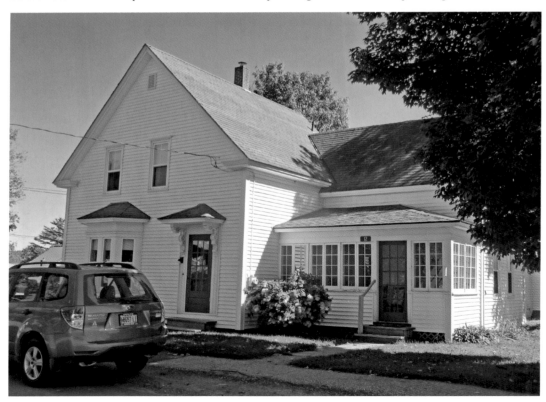

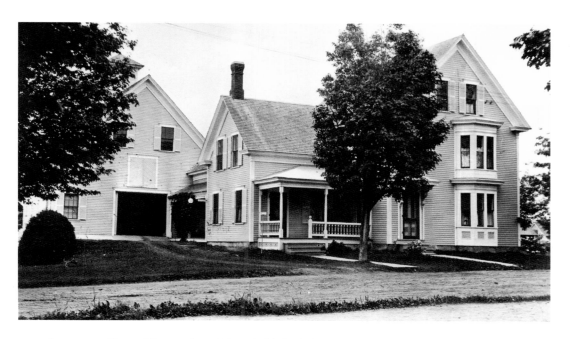

JEREMIAH ELLIS HOUSE: Jeremiah probably built the house prior to 1891. He sold it to Gerri Proctor, a local store owner, that year. Dr. Fred Colby bought the house in 1913 and remodeled a portion for his office. It was sold to Reed (grandson of Jeremiah) and Katherine Ellis in 1922 and it has been in the Ellis family since then.

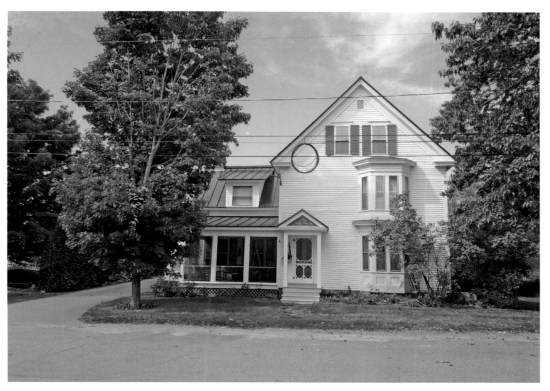

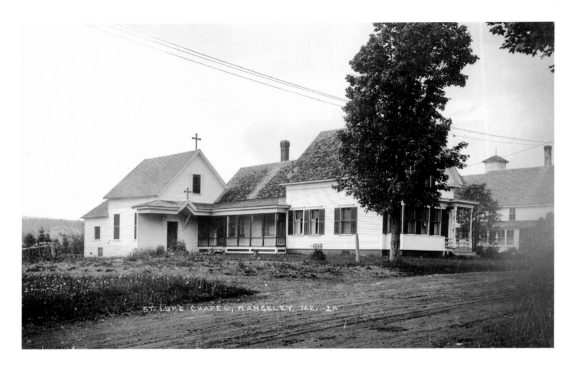

CATHOLIC CHURCH: The Catholic Diocese purchased the house and barn on this lot in 1914. The house became the rectory and the barn was converted into a chapel known as St. Luke Catholic Church. In the 1960s a large addition was added and it remains a church to this day.

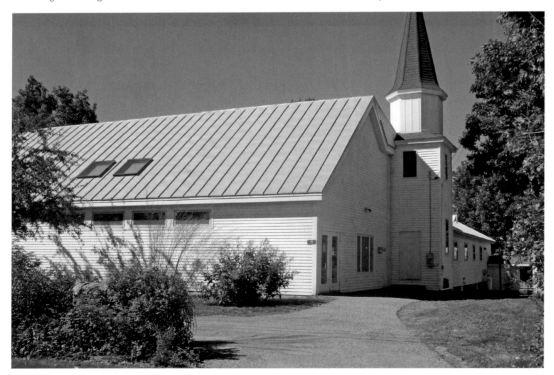

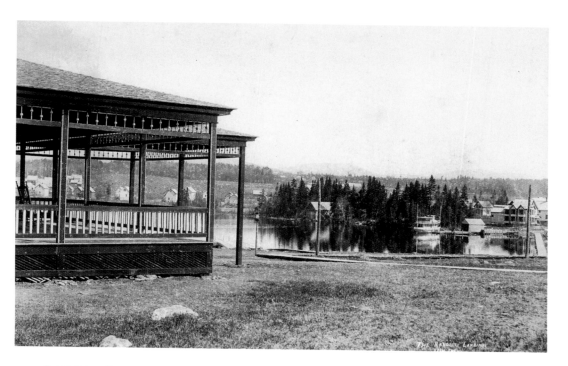

LAKESIDE PARK: The house on the far right was originally a single story dwelling built by William Lamb in the early 1880s. It was moved or demolished about 1928. Harry Furbish acquired the property in 1938 and in his will he donated the property to the Town of Rangeley to be used as the Town Park and it has served picnickers and bathing enthusiasts ever since.

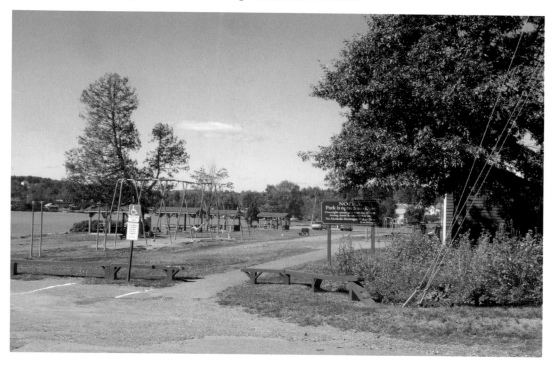

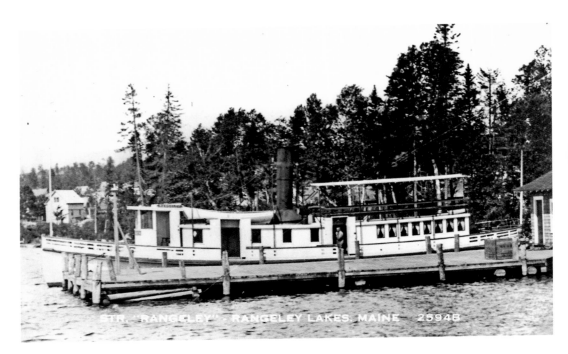

STR. "RANGELEY" - RANGELEY LAKES. MAINE - 25948

STEAMBOAT DOCK: Steamboats began operating on Rangeley Lake in 1876 with the Rangeley terminus being what locals call the "Town Dock" at the foot of Lake Street. Here the steamer "Rangeley" is tied up with just a portion of the ticket office visible on the right. When the steamboat era ended, the town took over the dock and still maintains it as part of the Town Park. In the 1950s there was a diving tower at the end of the dock.

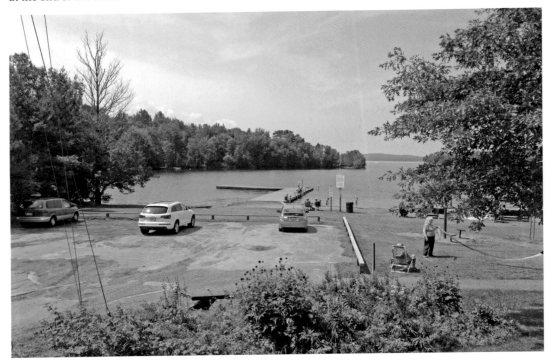

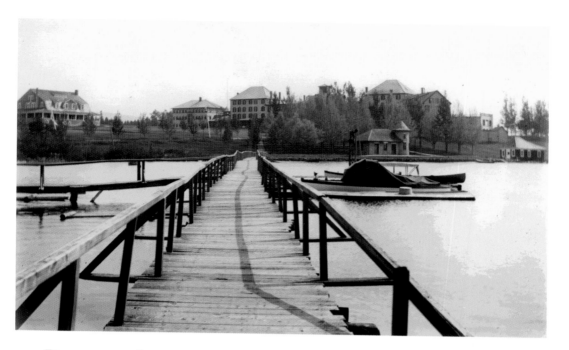

FOOTBRIDGE TO RANGELEY LAKE HOUSE: In 1908 the town built a footbridge from the Town Dock to Marble Station. Seen on the left is the Casino (dance hall), Rangeley Lake House in the background, and Marble Station in front. After the Rangeley Lake House closed in 1958, the bridge slowly decayed and was eventually removed. The only building visible in 2014 is the old Marble Station on the right.

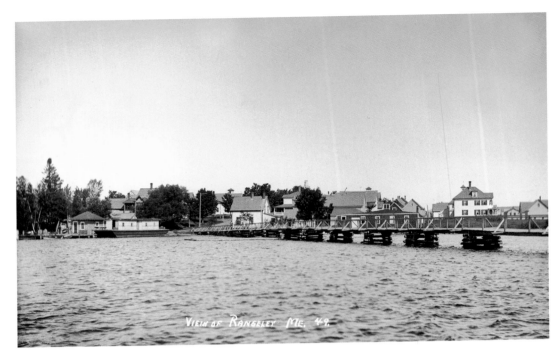

VIEW FROM MARBLE STATION: In the foreground is the footbridge. Identifiable buildings from the right are Phineas Richardson House, Clyde Ellis Boathouse, Mabel Case House, barge with a building ready to move, and the steamboat ticket office. The 2014 photo shows the Town Park with the Town Park Condominiums in the center background.

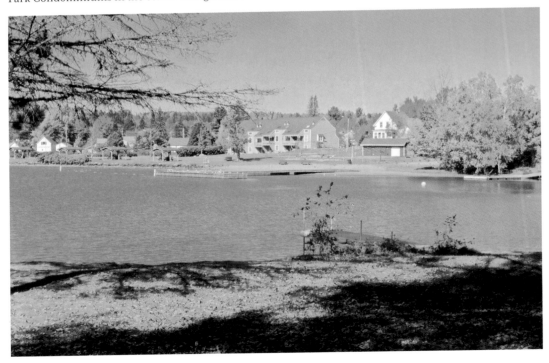

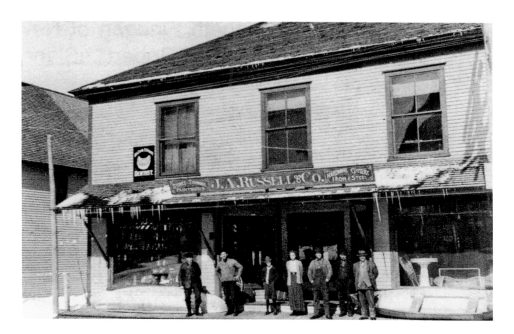

M. D. TIBBETTS HARDWARE STORE: The Haley Bros. operated a small variety store on this spot in 1880. In 1888 a new structure was erected and John Haley ran a general store. The premises were sold to the Rangeley Mercantile Company in 1897 and in 1901 John A. Russell leased the building and moved his hardware business here. It remained a hardware business for over 100 years under the ownerships of M. D. Tibbetts and Emery Scribner families. In 2014 it houses a mail-order business in the basement; restaurant, graphics design and real estate business on the first floor. The second floor has been a dentist office, telephone exchange, and has two apartments in 2014.

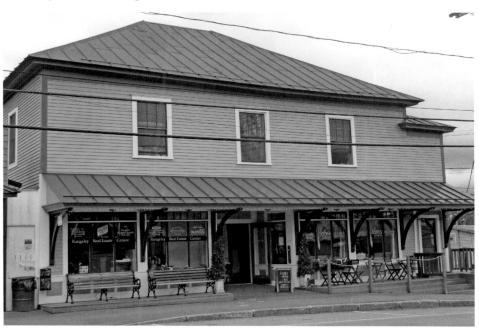

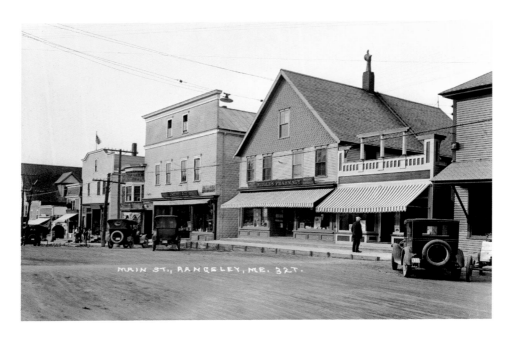

RIDDLE'S DRUG STORE: E. H. Whitney moved his drug store into this building on the right in 1908 and sold his business to Harry Riddle two years later. Riddle then merged his drug store with it and renamed it the Rexall Store; however, it was always referred to as Riddle's. A soda fountain was added in the 1940s by Joe McLafferty and it became a popular spot for the residents to congregate. Later it was enlarged by annexing the building next door which had been the office of the Rangeley Record. The drug store closed in 2008 and an internet café, The Inner Eye, opened four years later.

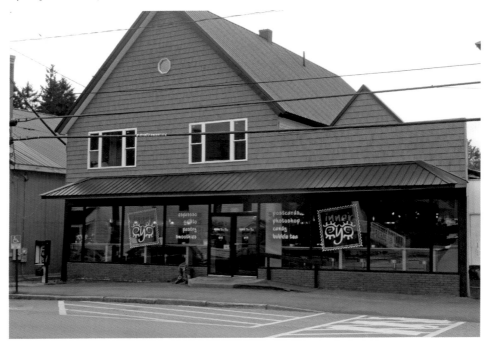

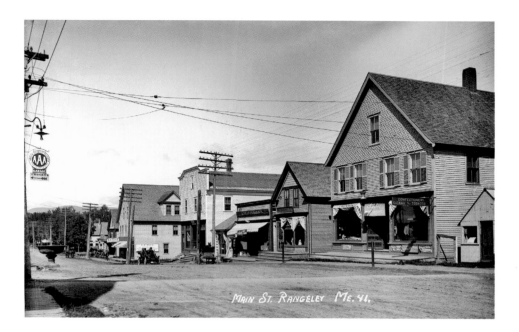

RUSSELL BLOCK: Prior to 1911 these three small buildings in the center were on the property. On the west end was a barber shop, a drug store and a millinery store. They all were relocated in 1911 and John A. Russell then constructed a three-story building to house his hardware and plumbing business. The second floor held a large meeting hall called Russell Hall. In 1960 the hardware store ceased operation and it became a grocery store. The building burned in 1994 and was replaced by a new movie theater in 1996 which, in 2014, became the home of the Rangeley Friends of the Arts.

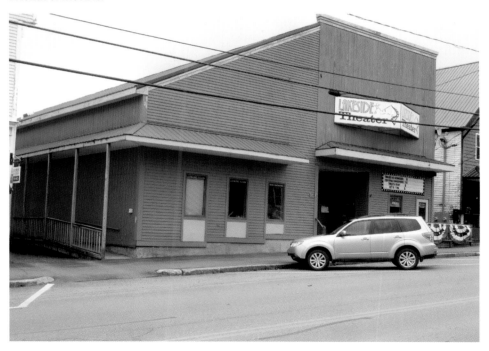

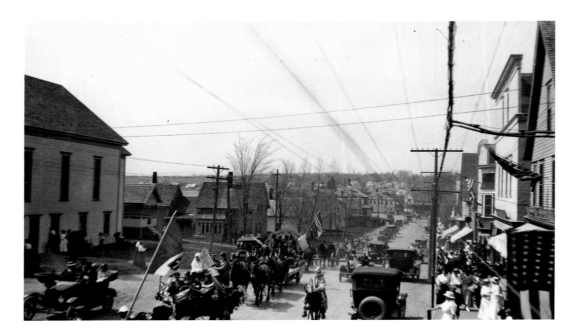

PARADE ON MAIN STREET: Rangeley loves parades and the above is probably the same parade as on page 45. This shows the Baptist Church, Town Bandstand, Sarah Soule House, Boardman McCard House, Albee House, Kempton House and, in the distance, the George Wing Store. In 2014 we can see a corner of the Baptist Church, Alpine Shop, Backwoods Clothing, Parkside and Main Restaurant and Miller's Bed & Breakfast.

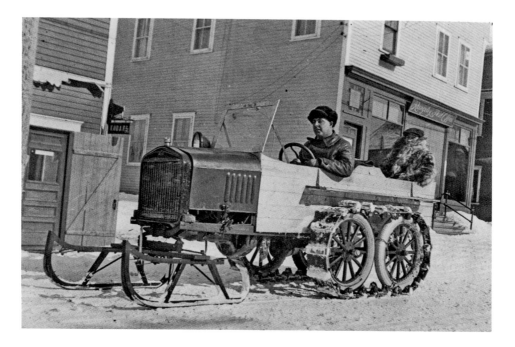

OLD POST OFFICE: The house originally located here was moved to Middle (now Center Street) in 1900 and the current structure erected in 1902 as a post office with an apartment upstairs. It remained the post office until 1967 when it relocated to its present building. Since then this place has functioned as a real estate/law office, a furniture store, and in 2014 the Rangeley Fireplace and Stove Co. opened here.

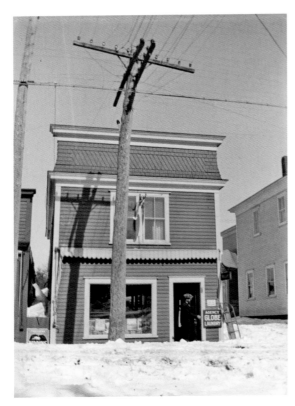

KODAK SHOP: In 1916 J. Sherman Hoar opened a film business later known as the Kodak Shop and operated it for over forty years. It was turned into a drug store in 1949. Ramona Oakes converted it into Mo's Variety in 1964 and it continued in business until 1991. It is now a consignment shop with the same name. Perhaps the fondest memories of two generations of locals and tourists alike was when "Mo" and her sister, Virginia, sold penny candy that attracted legions of children and adults.

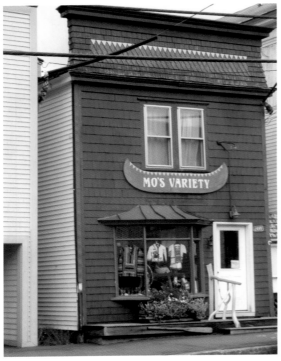

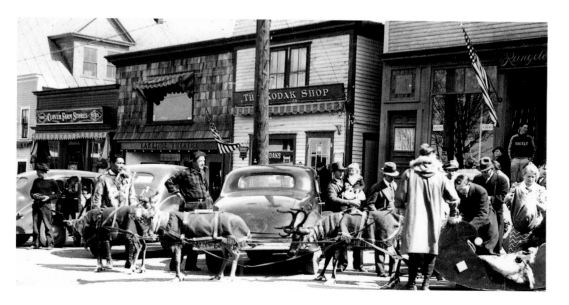

LAKESIDE THEATER AND CLOVER FARM STORE: The original theater was a grain storage shed that was converted into the Pavilion Theater in 1923; later it was known as the Lakeside Theater and in 1946 as the Playhouse Theater. It was destroyed in the fall of 1989. Next to the theater was Hemp's Lunch, later Clover Farm Store, and, still later, a gift shop named Cargo Express that was also razed at the same time as the theater. In 1990 Tony Jannace erected the current building as a gift shop. It is now the Saddleback Realty office in 2014.

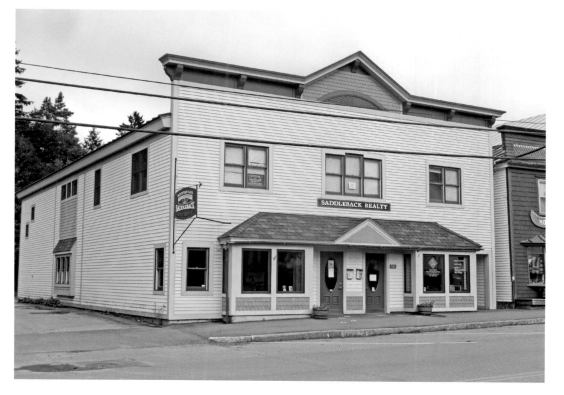

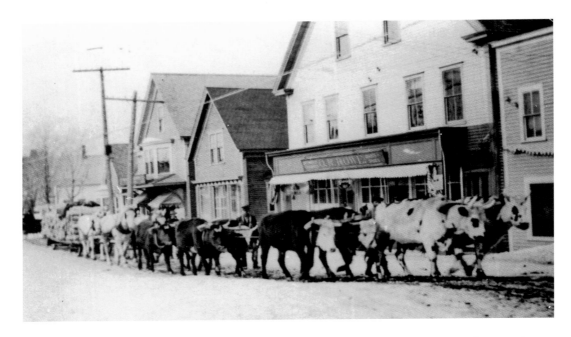

ROWE'S STORE: Gerri Proctor opened a general store here in 1880 with a meeting room on the second floor known as Franklin Hall. Proctor sold the store to Olin Rowe in 1907 and he remodeled it in 1915. Rowe specialized in dry goods, ladies and men's furnishings, and shoes. He took over an undertaking business in the 1920s and stored his caskets on the second floor. His son, Kenwood, ran the store from 1948-1965. The building was razed in the early 1970s and the lot now serves as the driveway for the Red Onion and Saddleback Realty.

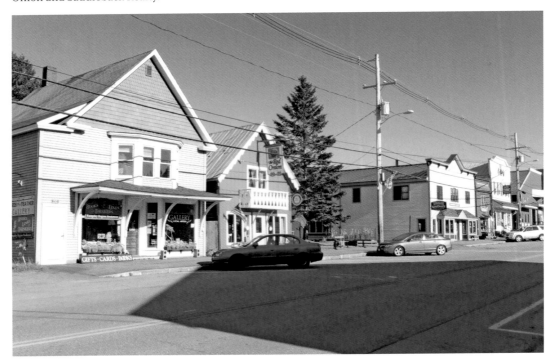

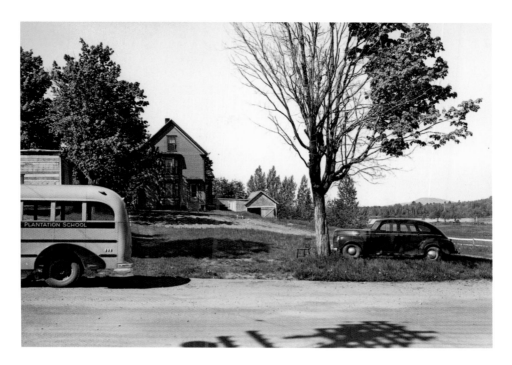

SHERMAN HOAR HOUSE: Originally the George Young House, it was located on the corner of Main and Lake Streets where the Skowhegan Savings Bank was in 2014. In 1922 it was moved to its current location and purchased by J. Sherman Hoar for his residence. It is the home of the owners of the Alpine Shop in 2014.

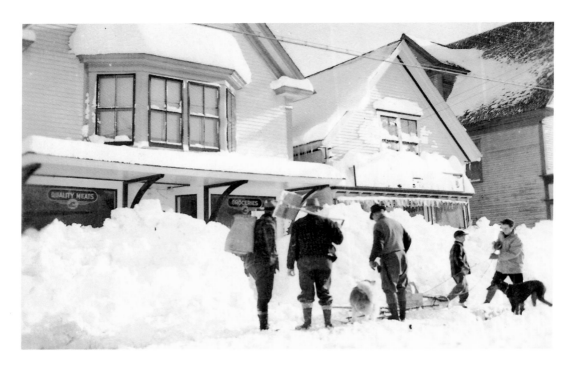

TAYLOR'S IGA: The original building (on the right) was moved to this location from Hatchery Brook about 1915 and George Beeh ran a bakery. Leo Taylor and Ray Fox ran a grocery store from 1919-1935. Fox sold out in 1935 and it became L. E. Taylor & Sons. After the IGA relocated to the old Johnson's Market in 1957, it became a pizza parlor. It has been known as the Red Onion since 1969 when Skender Leidl bought the business.

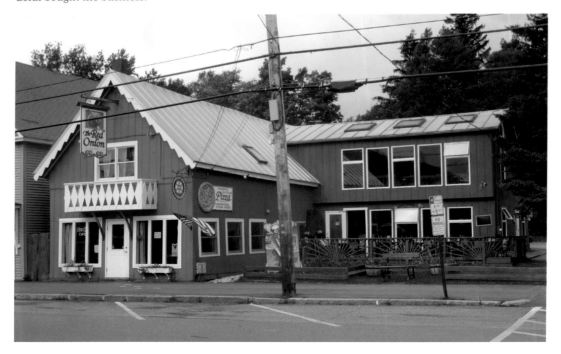

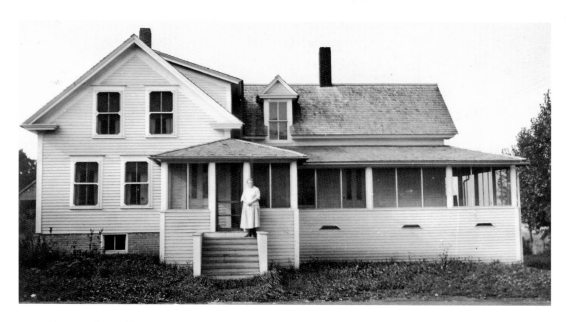

FRANK CASE HOUSE: Boardman McCard probably built this residence at the turn of the nineteenth century. It was sold to Frank and Ruth Case in 1941 and remained the family home until 2002 when it was demolished by "Tony" Jannace Jr. and a store, Backwoods Clothing and Embroidery, was erected.

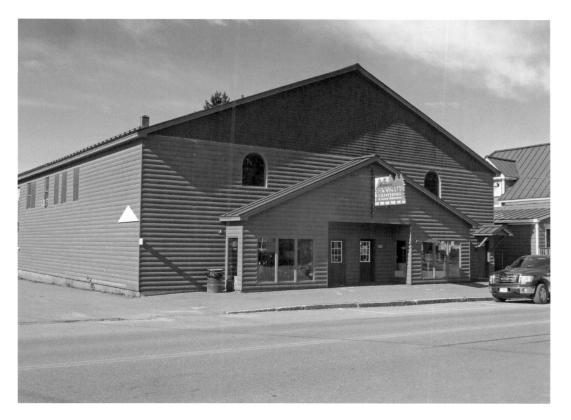

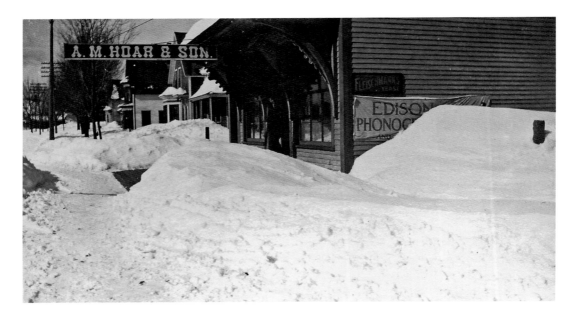

ANSON HOAR STORE: George Esty and Lyman Toothaker opened a meat market in this building in 1892. It continued as a grocery store under Harry Kimball, Willie Tibbetts, Anson Hoar, Eugene Herrick, Vance and Karl Oakes until 1972. Since then it has served as a number of different business and in 2014 was a book store named Books, Lines and Thinkers.

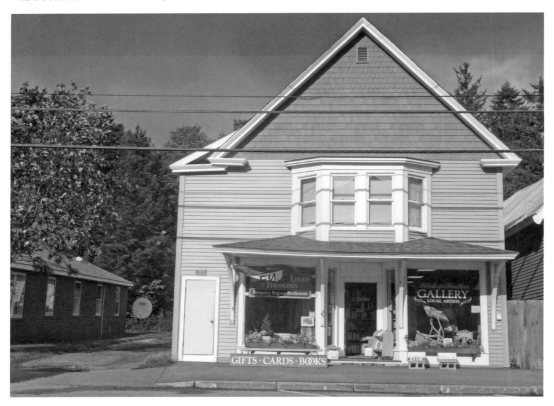

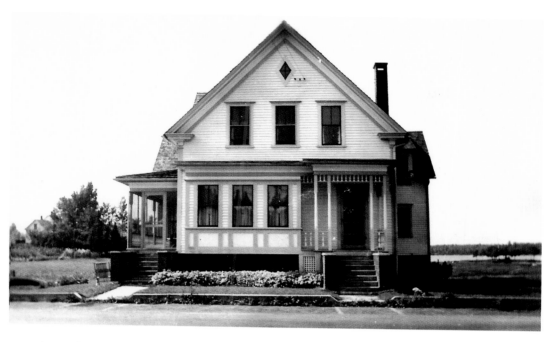

ALBEE HOUSE: The house was built about 1900 and owned by Violetta Albee, whose husband, Nathan, was a local guide. It was maintained as a private home until about 1942 when Marcia Sprague opened a boarding house to accommodate traveling salesmen. It was converted into a restaurant in 1974 and has operated as a restaurant under several names, most recently as Parkside and Main.

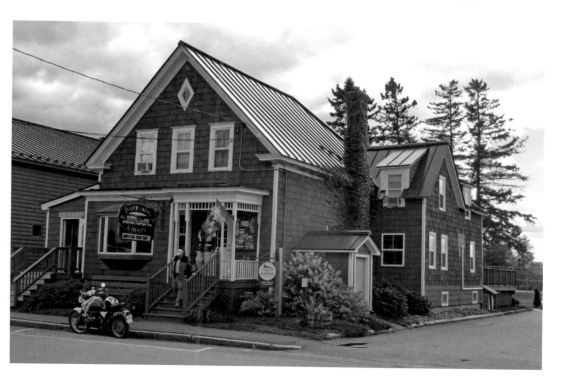

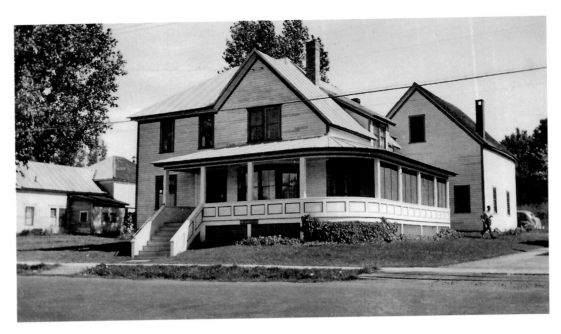

JOHN MOULTON HOUSE: A large two-story home with a stable, for many years it was the residence of Jeremiah and Emily Oakes. In 1925 Dr. John Moulton established his medical practice and residence in this building. He served the town for over thirty years and since his death it has been a private residence.

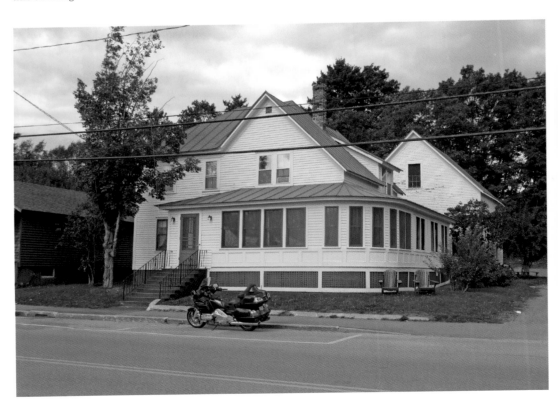

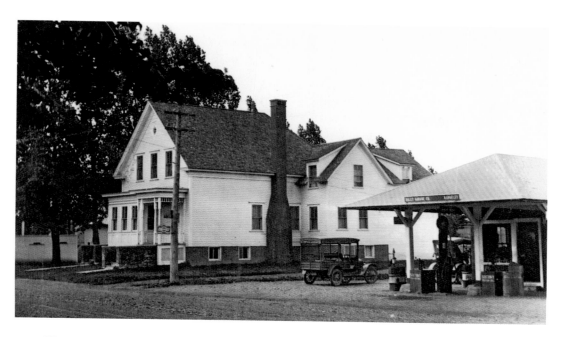

HALEY GARAGE: It was originally a stable and was later converted into a workshop. Orrie and Errol Haley operated a garage here in the 1920s. Harry Furbish bought the property in 1928 and later donated it to the town. A memorial to WWI veterans was dedicated in 1936; one to WWII, Korean War and Vietnam veterans in 1976; and another to veterans of Grenada, Lebanon, Panama, Persian Gulf and Somalia in 1995. These were replaced in 2002 by a new granite memorial dedicated to Rangeley veterans of all wars.

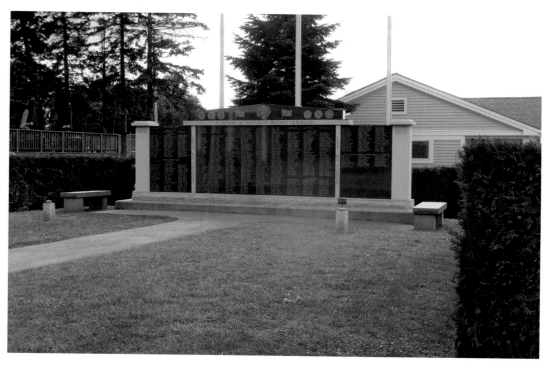

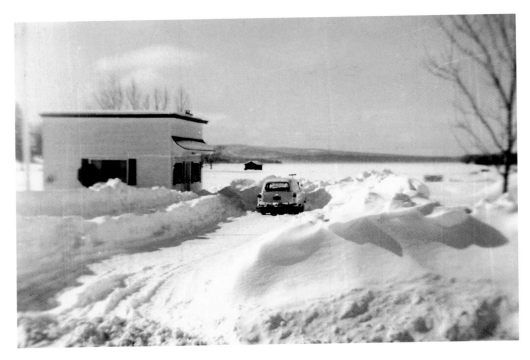

THE CHAMBER OF COMMERCE: Incorporated in 1955, its first home was above the then Main Street Market. They purchased an old fur trapper's building formerly owned by "Bert" Herrick and had it moved from High Street to Lakeside Park, where it was converted into an office. In 2007 and 2008 it was remodeled and the long-awaited public restrooms were added to the downtown area.

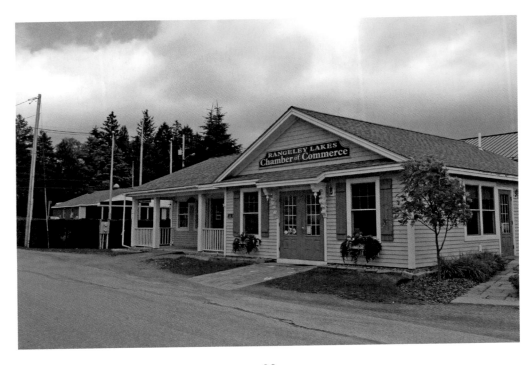

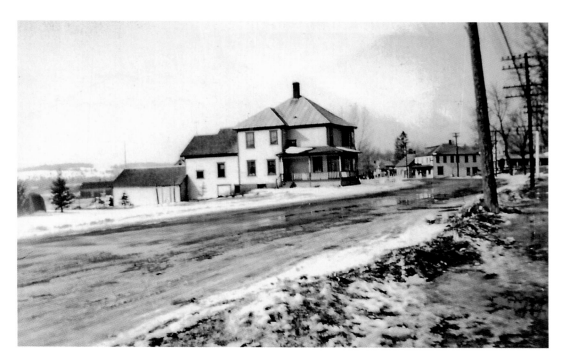

FRANK KEMPTON HOUSE: Frank Kempton built this house in 1911 and it remained in his family as a private home until 1946. Since then it has operated off and on as a tourist home, primarily hosting traveling salesmen by the Roland, Thompson and Eastwood families. It became a bed and breakfast in 2009 when Alexander "Sandy" Miller took ownership.

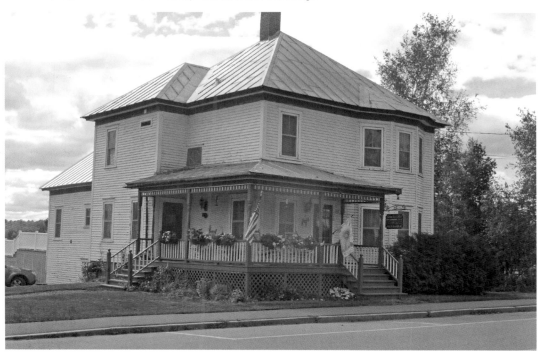

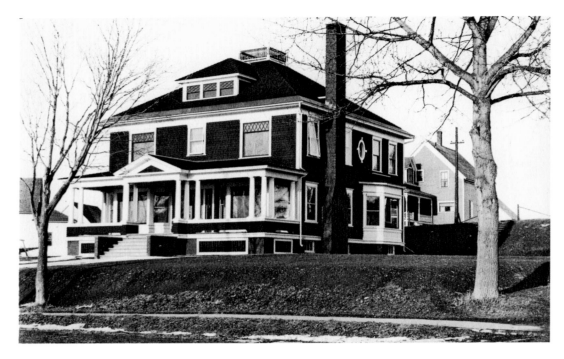

HARRY FURBISH HOUSE: Furbish bought property in 1887 and lived there until 1914. He then moved that house to High Street and built the current house in 1915. It is a colonial-style house, 37'x37' with four rooms downstairs and four upstairs. It was a private residence until the early 1990s when it became a bed and breakfast – now known as North Country Inn B & B.

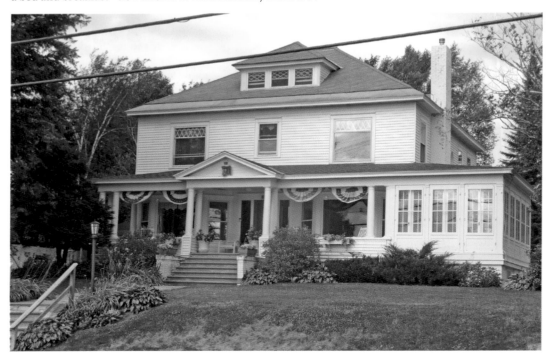

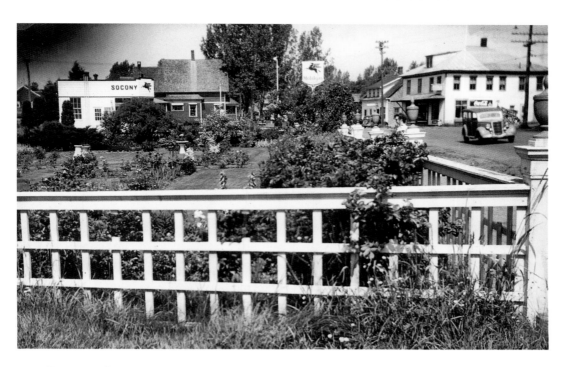

FURBISH GARDENS: Harry Furbish created a formal flower garden across Main Street from his house in the 1920s. For many years the beautiful blossoms were an attraction for visitors and locals alike. Though it has had several owners over the years, it still remains a garden, however on a much more limited basis.

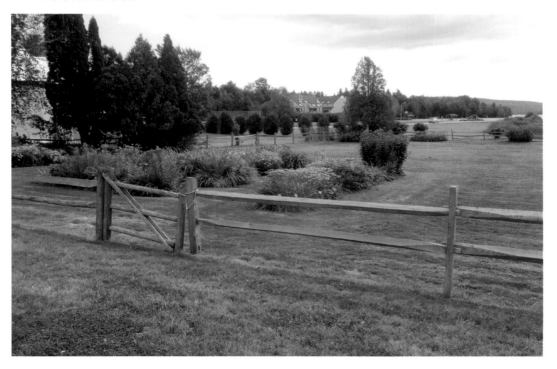

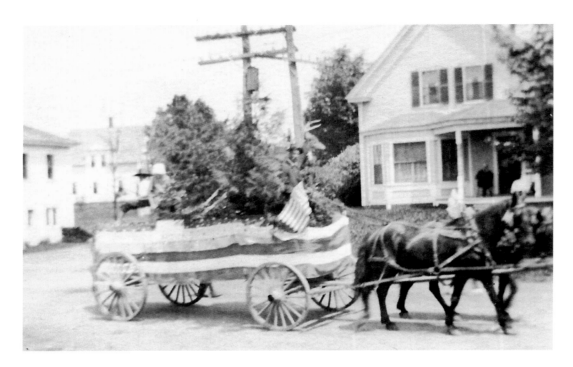

EBEN HARNDEN HOUSE: Eben Harnden, a local guide, built this house in 1907 (on the right). The old photo shows a 4th of July parade about 1910. His son, Ray Harnden, sold the house to Annie Pillsbury in 1944 and it later was the home of Ben Morton. The house burned in 1956 and has never been replaced.

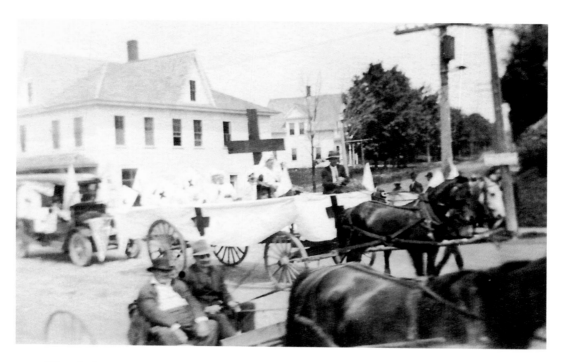

WING'S STORE: George Wing operated a grocery store here as early as 1901 (building on the left). Later store operators were Clark Smith, Fernald Philbrick and Chester Johnson. It was razed in 1967. The house is the background was owned by Aaron Soule.

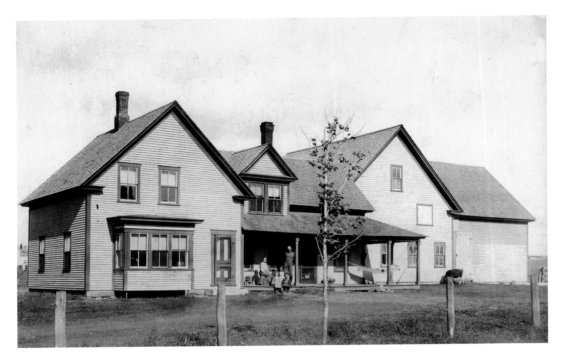

CONGREGATIONAL BARN: John Huntoon erected the original house and sold it to David Hoar in 1898. It remained in his family until 1961 when Frank Porter sold it to the Union Congregational Church. The church sold it in 1968 but repurchased it in 1984. The house portion is used as the church office and a day care center; the old barn has been converted to a function hall complete with a kitchen.

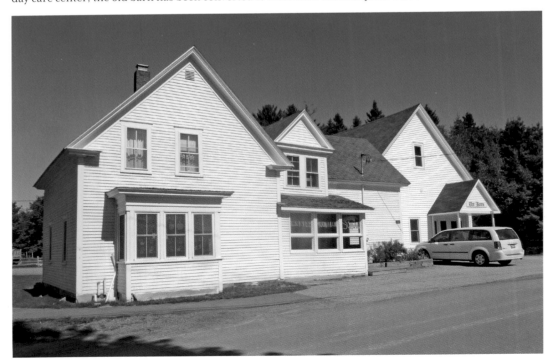

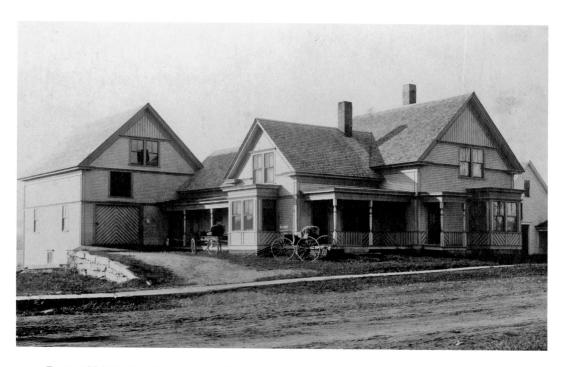

EARLE HUNTOON HOUSE: Earle Huntoon owned this house in the early 1900s. It was acquired by the Episcopal Church in 1964, the building demolished and a new church erected. It is also used for summer concerts and other events.

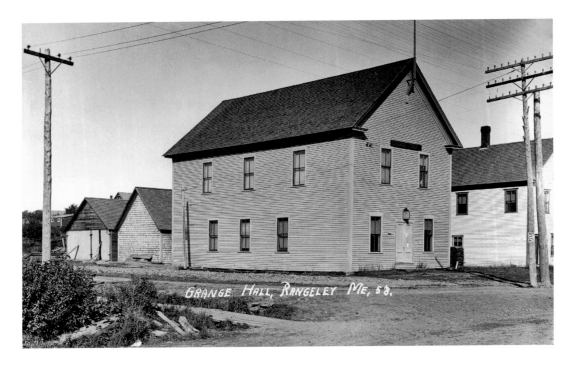

GRANGE HALL: In 1891 the Town of Rangeley acquired the land from Elias Haley. The original two-story building was a Grange Hall and later became the Town Office. When the schoolhouse burned in 1911 and 1912, classes were conducted on the second floor. It was converted into a garage in 1927 by Axel Tibbetts and has been a garage ever since. The original structure was razed in 1961 by Lee Davidson and the garage was erected.

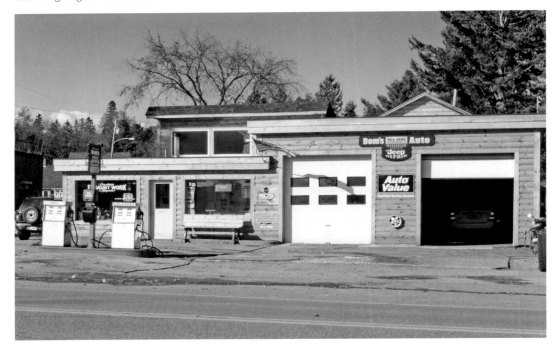

THE KIDDER RESIDENCE AND THE KNOTHOLE: In 1946 John and Dorothy Kidder opened a hot dog stand here. It became a popular stopping spot particularly for the "after movie crowd" at 9 and 11 p.m. Business was so good that a year later they doubled the size, and soon after they added a Clam Shack in the rear, specializing in fried clams. Their home is shown in the background. The Knothole and Clam Shack were removed in the late twentieth century.

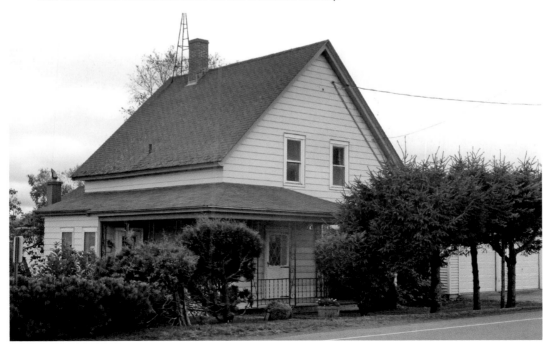

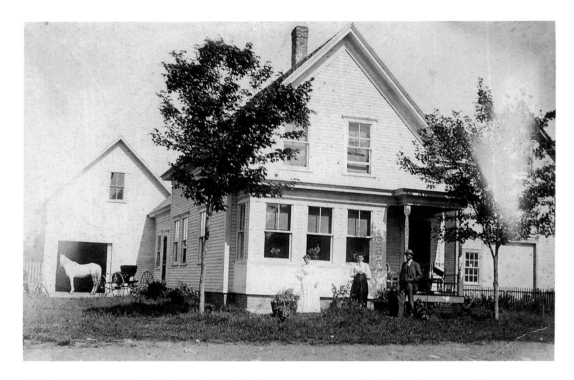

OLIN ROWE HOME ON ALLEN STREET: The house and barn were built by Andrew Newell Dunham prior to 1891, when he sold it to Eben Rowe. Rowe's son, Olin, operated a funeral home here until 1958 when Maurice Thibault took it over. The house and barn burned to the ground in early 1981. The second floor of the large barn had been a basketball court and many of Rangeley's basketball players of the 1940s and 1950s developed and honed their skills here. The current home, shown in 2014, was built in the 1980s.

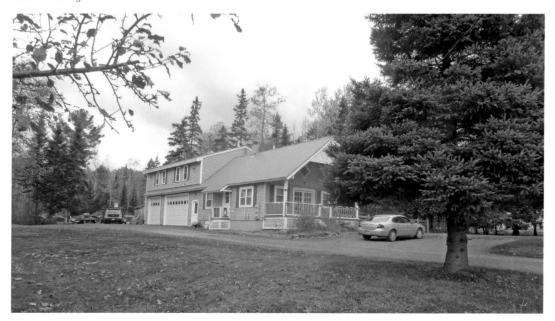

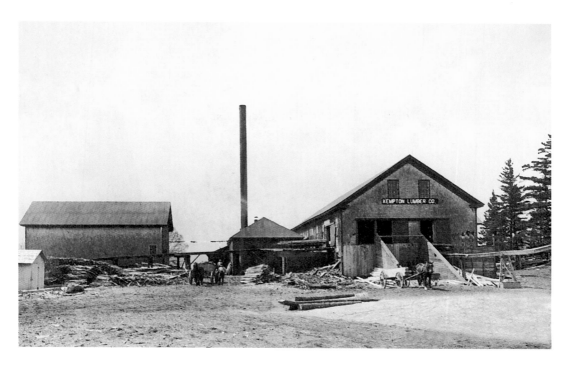

KEMPTON MILL: The first mill was built in 1901 by Lafayette Kempton and known as Kempton Lumber. It burned in 1915 and was rebuilt. In August 1939 fire again leveled the sawmill and three storehouses. It was rebuilt again and in operation within months. It closed in 1944 and in 1948 the Rangeley Lumber Company restarted it and operated it until 1954, when it closed for the final time. The fine home now on the lot was constructed in 2010.

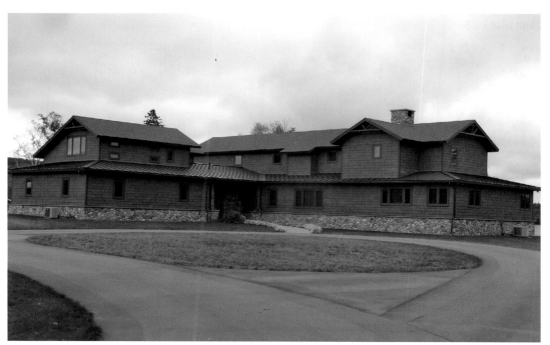

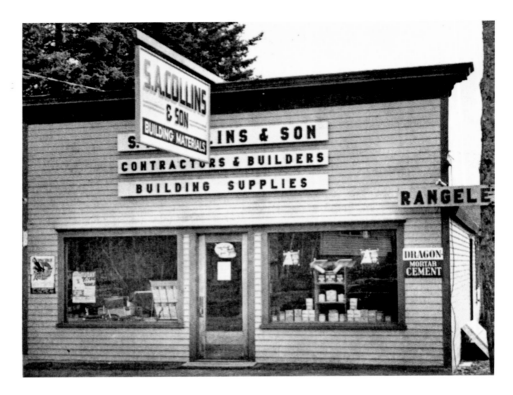

S. A. COLLINS STORE: Chester Johnson opened a produce market in 1925 and later enlarged it and sold poultry. In 1947 S. A. Collins & Son opened a paint and lumber store. The business was sold to Gary Patnode in 1982 and named the Rangeley Lakes Builders Supply. He constructed a brand new store and lumber shed and in 2014 added a showroom for the furniture business known as Welcome Home, previously located next door in the old S. A. Collins residence.

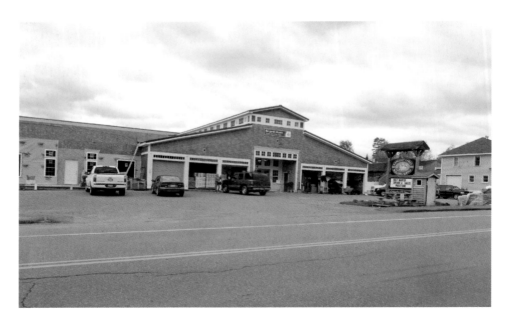

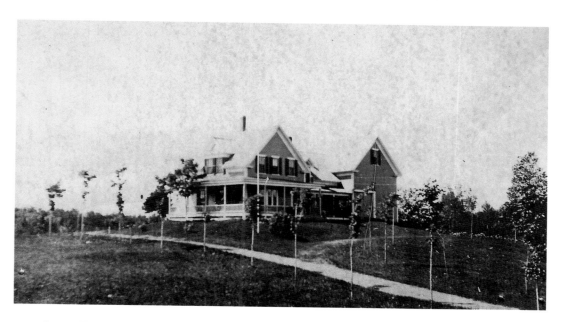

JULIA HINKLEY HOUSE: Carrie Russell, wife of J. A. Russell, purchased the house from Julia Hinkley in 1901. Their daughter, Isabelle, opened the Birch Point Tea Room in a converted boathouse on the lakeshore in 1922. In 1925 Russell Motor Camps opened and one room became the office. The house and camps remained in the family until 1988 when the property was sold and the camps converted into condominiums.

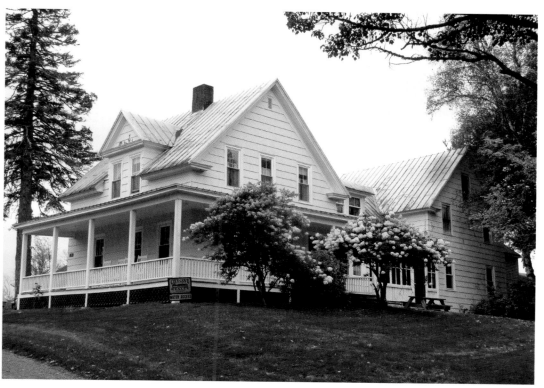

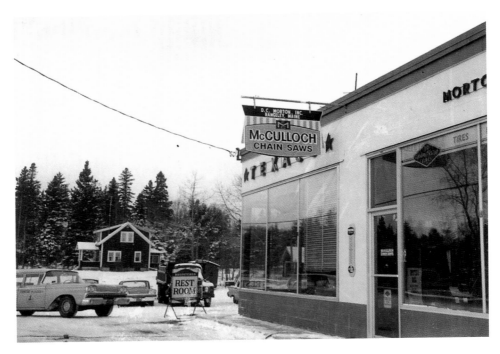

MORTON'S GARAGE: Donald "Bart" Morton purchased the property in 1958 and relocated the house to the next lot on Loon Lake Road. He then constructed a garage, service station and office for his trucking and logging operations. He and his sons operated the enterprise until 2004 when it was sold. Since then the service station portion has been remodeled to include a mini mart called the Looney Bin Variety. The garage, in the rear, has been converted into a recreational vehicle sales and service shop under the name of Boss Power.

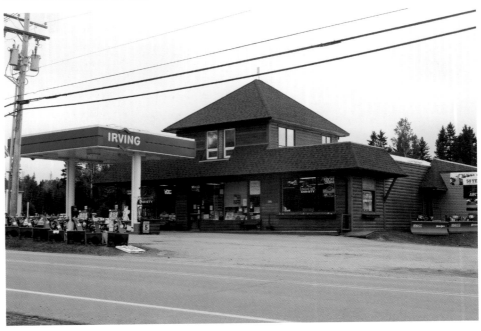

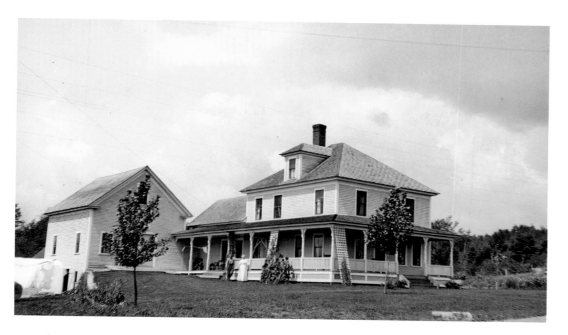

CORNELIUS RICHARDSON HOUSE: This farmhouse was built about 1912 by Cornelius and Annie Richardson. He had been the superintendent of the Oquossoc Angling Association for nearly 30 years before retiring in 1899. They sold it to Minnie Pillsbury in 1925 and it has been in the Pillsbury family since then. In 2014 it was the home of Dorothy Pillsbury and her daughter.

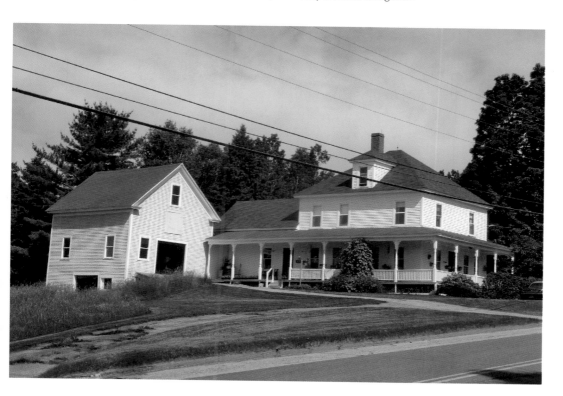

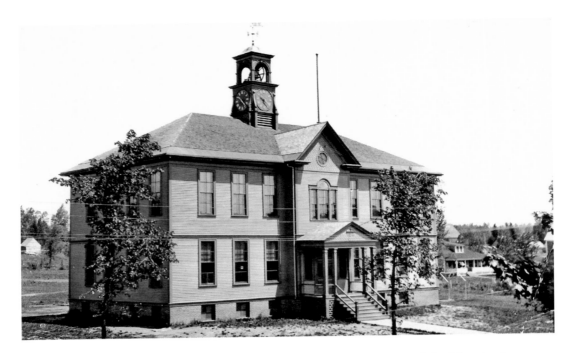

RANGELEY ELEMENTARY SCHOOL: The old two-story wooden building on School Street, where several generations of Rangeley children were educated, was opened for the spring term of 1904. It burned in October 1911, was rebuilt and burned again in November 1912. It was reopened in the spring of 1913 and housed all grades until the high school building opened in 1927 when there were 375 students in the entire school system! The building was demolished in 1979 and the Town Office building erected immediately. The safety building was erected in 2004 next door.

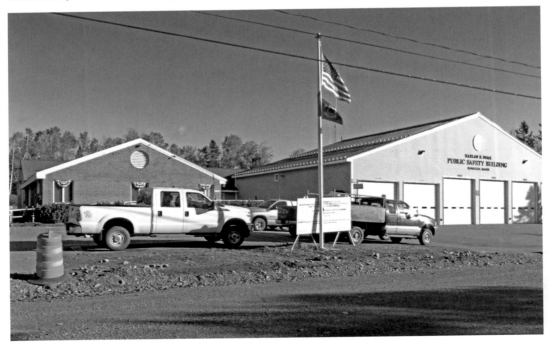

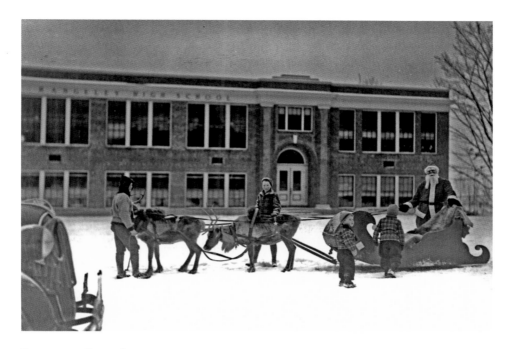

RANGELEY HIGH SCHOOL: In the 1920s Rangeley found its high school enrollment exceeding 100 students and elected to build a separate high school building. It opened across the street from the elementary school in 1927 and remained the high school until 1978 when the new structure off Loon Lake Road was built. The old building was vacant for many years before being converted into twenty-two apartments for low income and elderly citizens in 1983; it is called the Rangeley Townhouse Apartments in 2014.

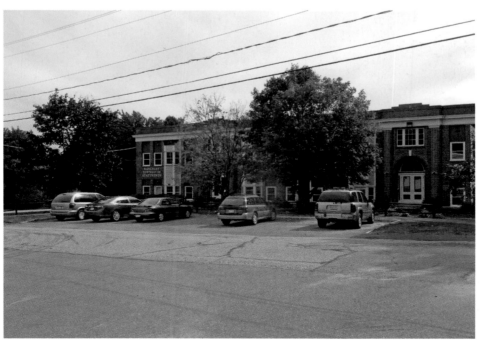

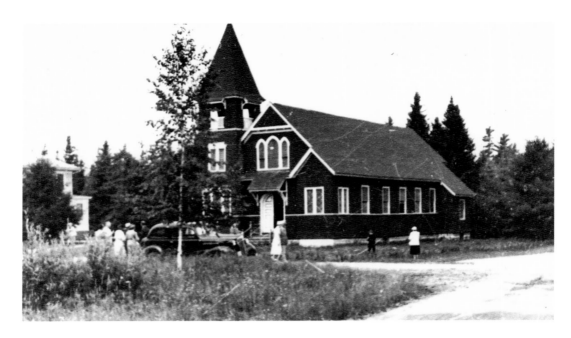

OQUOSSOC CATHOLIC CHURCH: The first Roman Catholic Church in the region was established in 1908 and is still known as "Our Lady of the Lakes." Flyrod Crosby, the first registered guide in the State of Maine and a champion supporter of the Rangeley Region, was very instrumental in establishing the church and raising the funds to build it. Father Paul Plante has just completed his tenth year as pastor here in 2014.

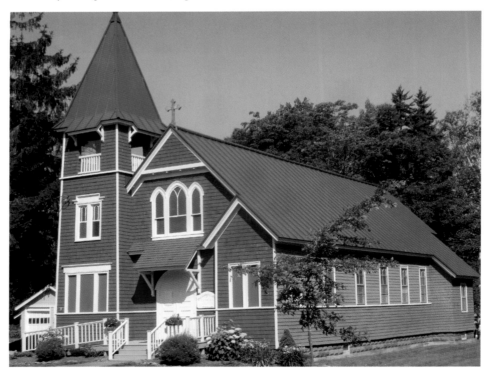

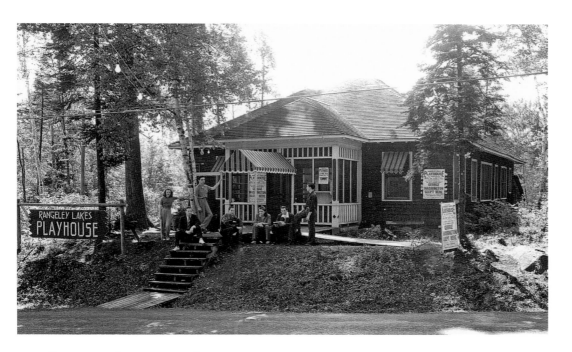

OQUOSSOC COMMUNITY CLUB: It was built by several citizens of Oquossoc about 1940 and served as a function hall for dances and suppers. In 1941 Rangeley Playhouse Theater staged theater events here. After WWII it was known for weekly whist parties, square dances, Halloween and Christmas parties. It was converted to retail purposes in 1981 and in 1994 became a fishing tackle and supply store called River's Edge Sports.

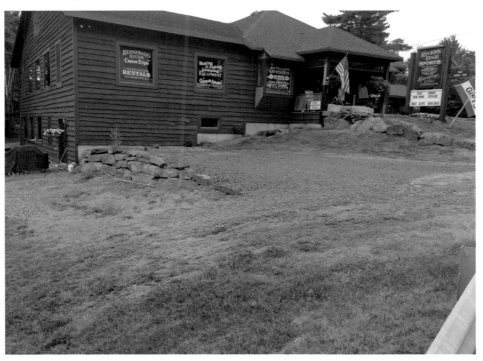

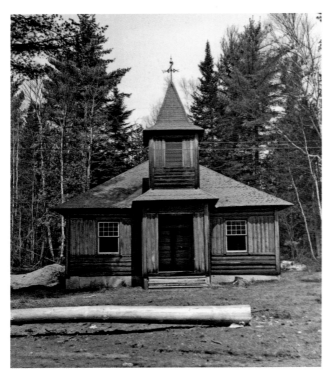

OQUOSSOC UNION PARISH: This log church was built in 1916 by Anson Heywood and Leon Wright. It started as a non-denominational church with services only in the summer and continues to operate on the same basis today. The pump organ was built in 1916-1918 and is still in service in 2014. The church is also a popular place for summer weddings.

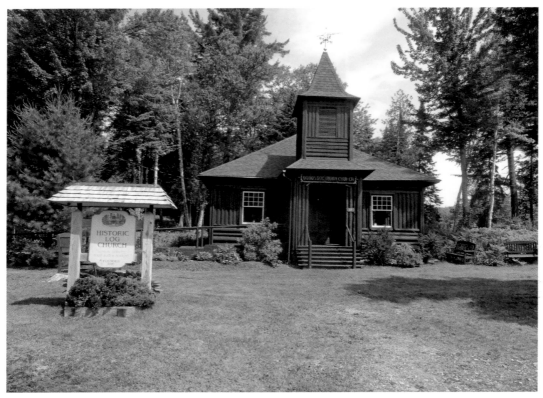

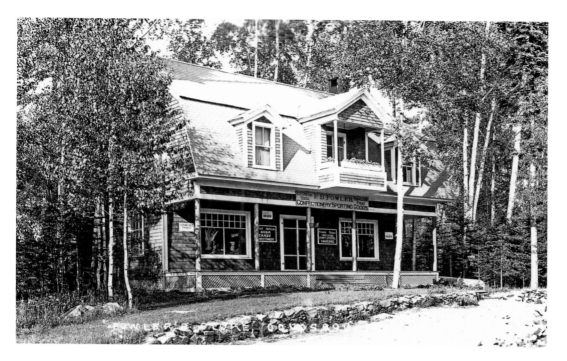

FOWLERS STORE: Fred Fowler opened Fowlers Sporting Goods in 1921 selling gifts and souvenirs. He also installed a large marble soda fountain and served fountain drinks and ice cream. In the 1970s Jim Blakely renamed it The Gingerbread House. The store was later extensively remodeled by Edson Mitchell and Ed Kfoury into a large modern restaurant. They retained the landmark soda and ice cream counter and it remains a popular evening destination to get a "delicious" ice cream cone as well as a meal.

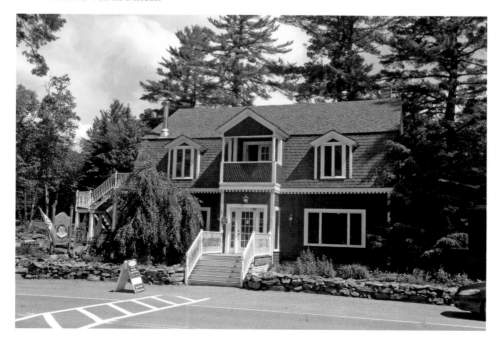

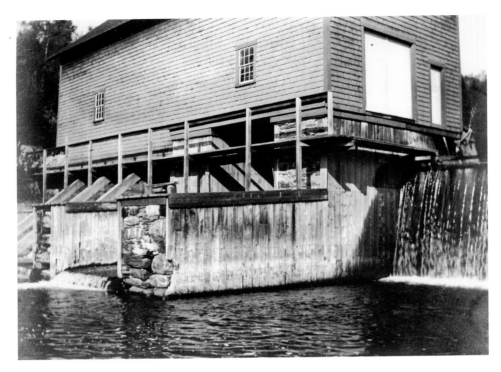

DAM AT OUTLET OF RANGELEY LAKE: Squire Rangeley built the first dam, along with a grist mill, and then a shingle mill in 1833. Whether any of these were located at the site of the present dam is unknown. Below the dam the Rangeley River flows into Cupsuptic Lake at the confluence of the Kennebago River.

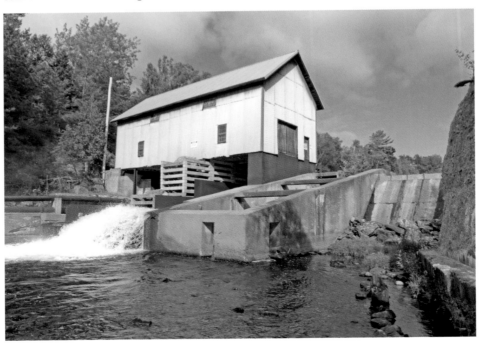

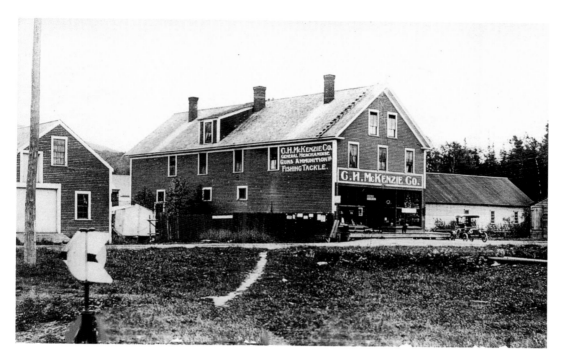

C. H. McKenzie's Store: The store was opened in 1902 to handle the increased freight brought in by the newly completed railroad. The store closed in 1934 and two years later Guy and Willard Judkins converted it into a hotel. In 1939 the first floor was renovated into a dance hall. Scotty MacPherson took over in 1947 and it was known as "Scotty's." It remained a bar and dance hall until 1973 when the dance hall was converted into a restaurant by Norman and Carmen Glidden. The building burned in 1999 and has not been replaced.

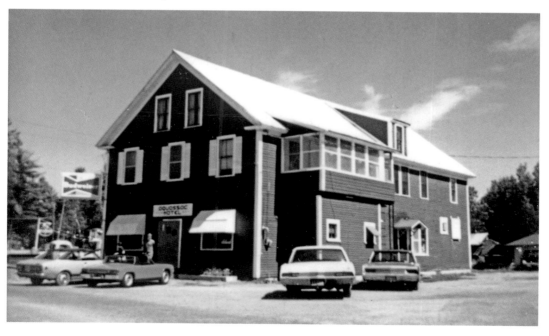

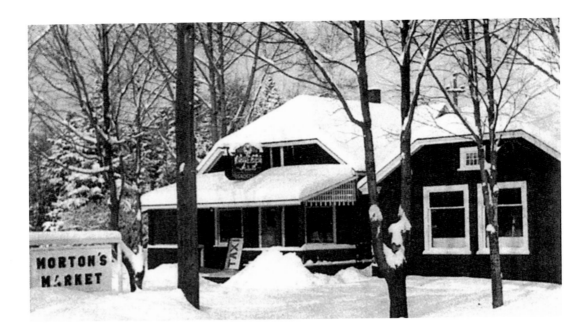

MORTON'S MARKET: The building was originally Bill Thomas's barbershop and was acquired by Ben Morton in 1946, converted into a grocery store and has remained as such since then. The structure was enlarged to its present size by Russ Hughes and is now owned by Brad and Kelly (Morton) Stokes. Kelly is Ben's granddaughter.

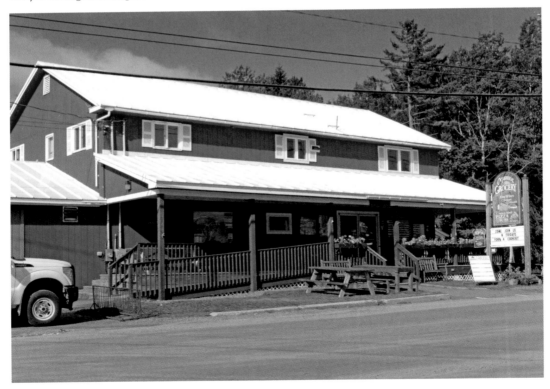

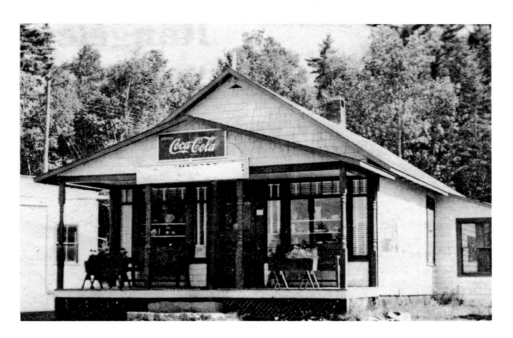

ARTHUR & ELLA QUIMBY'S STORE: Arthur ran the gas station and his wife, Ella, ran a gift shop and was the postmistress. The property has also housed a real estate office and antique store. The building was torn down and the land remained vacant until August 2010 when the Rangeley Lakes Region Historical Society built their Outdoor Sporting Heritage Museum. The museum, dedicated in 2011, contains an original trapper's log cabin, many large fish mounts from the early days of Rangeley, a Carrie Stevens exhibit of her famous flies, and hundreds of fishing memorabilia items of the area.

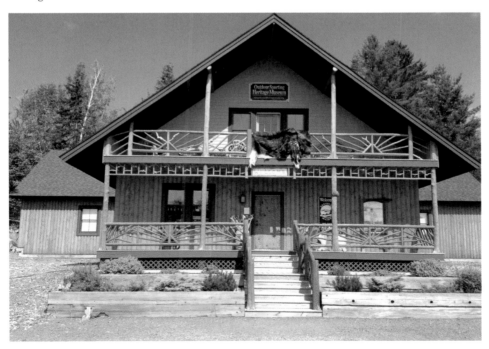

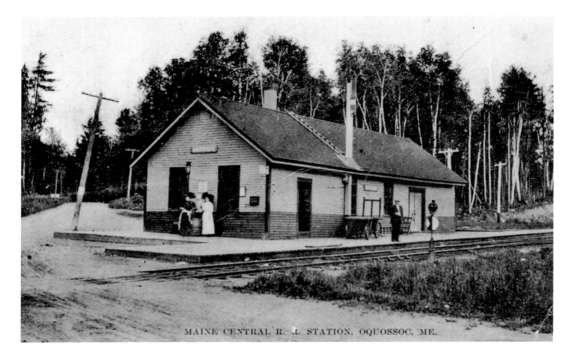

MAINE CENTRAL R. R. STATION, OQUOSSOC, ME.

OQUOSSOC DEPOT: The Rumford Falls and Rangeley Railroad was extended from Bemis to Oquossoc in 1902 and a depot was constructed. Rail service was discontinued in 1934 and the building was either moved or demolished. The property remained vacant for many years but now houses the Farmer's Daughter produce market, Scotty's Lobster Pound and Tall Tales Restaurant.

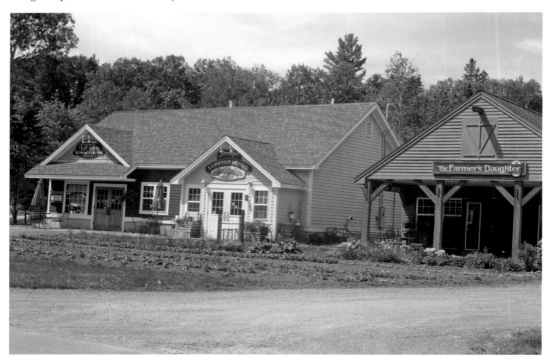

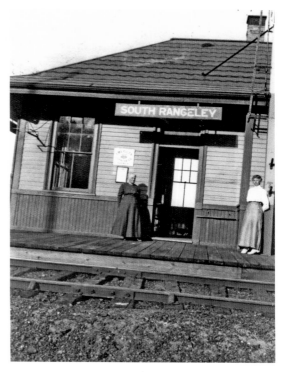

SOUTH RANGELEY DEPOT: The depot was built to connect the steamboats plying Rangeley Lake with the newly established train service from Rumford in 1902. Passengers arriving by train could connect to the various hotels and camps on Rangeley Lake without going on to Oquossoc and having to take a buckboard to the Oquossoc landing to catch the steamer. Train service was discontinued in 1935 and the fate of the old station is unknown. Louis Thalheimer has owned a large second home there since the early twenty-first century.

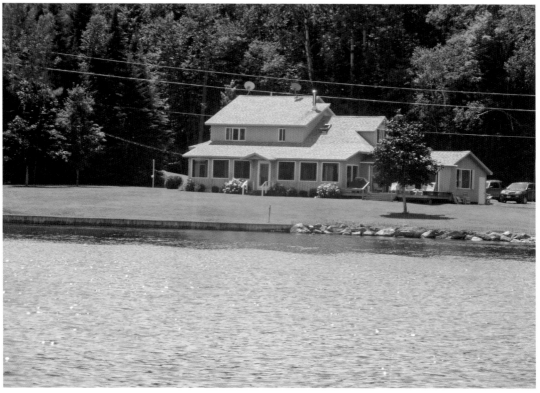

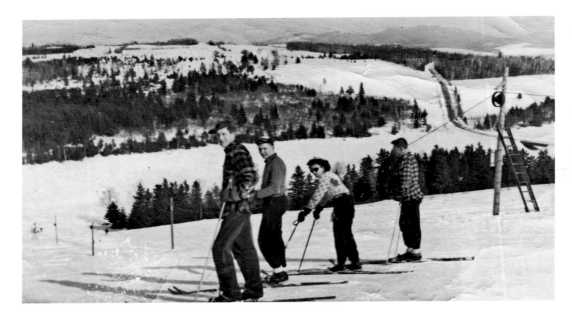

HALEY SKI TOW: A view at Hunter Cove.

ACKNOWLEDGEMENTS

Without the tremendous support of the Rangeley Lakes Region Historical Society, its board of directors and members, this book would not have been possible. The society's accumulation of post cards and photographs is outstanding and preserves a wealth of Rangeley's history. The majority of the old pictures came from their collection as well as the author's collection. All present day pictures were taken by the author.

Special thanks goes to Jay Hoar who donated to the Society a voluminous collection of early Rangeley negatives from his father's Kodak Shop which operated from about 1910 to 1948. After culling through hundreds of these negatives, depicting Rangeley from the early 1900s to the 1940s, I have selected several of them for this book.

I would like to thank the Penobscot Marine Museum for the use of pictures on pages 8a, 9a, 15a, 43a, 44a, 48a, 52a, 54a, 55a, and 76a and the following friends for these pictures: John (Jack) Kidder III for 11a, 13a, 14b; Guy Rioux for 12a; Connie Russell for 53a; Carl Eastwood for 66a and 69a; Carol (Dahne) Allard for 68a; Ann (Taylor) Wilbur for 77a: Sally (Rowe) Church for 78a; Dorothy (Morton) Novack for 82a; and Everett Quimby for 96.

Any omissions, additions or corrections should be addressed to the author at gnpriest@aol.com or Rangeley Lakes Region Historical Society, POB 521, Rangeley, ME 04970.